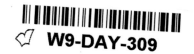

Goya
in The Metropolitan Museum of Art

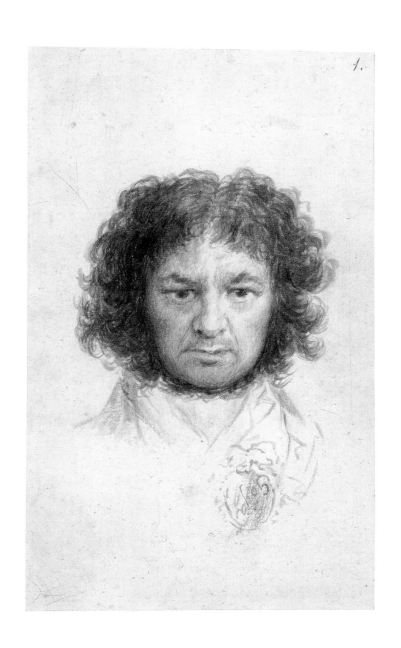

Goya
in The Metropolitan Museum of Art

Colta Ives and
Susan Alyson Stein

THE METROPOLITAN MUSEUM OF ART

NEW YORK

This publication is issued in conjunction with an exhibition held at
The Metropolitan Museum of Art, New York, September 12–December 31, 1995

The exhibition is made possible by

GOYA FOODS

Published by The Metropolitan Museum of Art, New York

John P. O'Neill, Editor in Chief
Barbara Burn, Executive Editor
Margaret Aspinwall, Editor
Tsang Seymour Design Studio, Designer
Matthew Pimm and Rich Bonk, Production
Robert Weisberg, Computer Specialist

All photographs are by the Photograph Studio, The Metropolitan Museum of Art, except figs. 10, 32, and 42,
which were supplied by the owners of the paintings.

Printed by Meridian Printing Company, East Greenwich, Rhode Island

Cover: Detail of *Don Manuel Osorio Manrique de Zuñiga* (see fig. 1). The Jules Bache Collection, 1949 (49.7.41)
Frontispiece: *Self-Portrait*, ca. 1795–1800. Brush and gray wash; 152 x 91 mm. Harris Brisbane Dick Fund, 1935 (35.103.1)

Library of Congress Cataloging-in-Publication Data
Metropolitan Museum of Art (New York, N.Y.)
Goya in the Metropolitan Museum of Art / Colta Ives and Susan Alyson Stein.
p. cm.
Exhibition held at the Metropolitan Museum of Art, New York, September 12–December 31, 1995.
Includes bibliographical references.
ISBN 0-87099-752-1 (alk. paper)
1. Goya, Francisco, 1746–1828—Exhibitions. 2. Metropolitan Museum of Art (New York, N.Y.)—Exhibitions.
I. Ives, Colta Feller. II. Stein, Susan Alyson. III. Title.
N7113.G68A4 1995
760'.092--dc20 95-24200
 CIP

Contents

Sponsor's Statement

Goya Foods is proud to sponsor the exhibition of the work of Francisco de Goya in The Metropolitan Museum of Art.

As our company celebrates its 60th Anniversary in 1996, we are as committed as ever to supporting community events that reinforce our rich Hispanic heritage, and take great pride in the knowledge that this stunning exhibition will be seen by thousands of visitors.

We are equally delighted that by supporting the works of one of the world's greatest artists, we are also paying homage to the homeland of my parents, Carolina and Prudencio, the founders of Goya Foods.

Our participation with the Metropolitan Museum is, in a sense, a coming together of fine art and the culinary arts—both of our institutions share an appreciation for quality and beauty.

Just as we have provided nearly one thousand fine food products to America's dinner tables since 1936, we are glad to make possible the Goya exhibition as a visual feast to be savored and celebrated. ¡Buen provecho!

Joseph A. Unanue
President and CEO
GOYA FOODS

Foreword

"Goya in The Metropolitan Museum of Art" reintroduces Francisco de Goya y Lucientes to our visitors through the Metropolitan's own collection, which includes a fine group of paintings and a high number of outstanding drawings and prints. Our intent is to show the breadth of Goya's creative genius and at the same time to reveal the strength and depth of the Museum's collection.

This exhibition is one in a series of efforts to explore particularly rich veins of material in the Museum in which the work of one outstanding artist can be examined across a broad range of media including painting, drawing, printmaking, sometimes sculpture, and even photography. Such past projects have featured the achievements of Greuze, Ingres, Delacroix, Degas, and Eakins; in the future, exhibitions will be devoted to our varied holdings of work by Rembrandt, Giandomenico Tiepolo, Winslow Homer, and Toulouse-Lautrec.

As it stands today, the Metropolitan's exceptional collection of works by Goya is very much an aggregate of the tastes, judgments, and prerogatives of many individuals. It was almost fully formed as early as 1936, when the Museum held its first Goya exhibition assembled mostly from its own holdings. While since then four drawings, including two self-portraits, and some working proofs of prints have been added, it is in the paintings representation, as noted in Susan Stein's essay, that the collection has

been significantly enlarged in number and revised by scholarship. Many will no doubt be surprised at the richness of the Metropolitan's holdings, at the institution's long-standing interest in the artist's works, and at the current controversies surrounding the authenticity of long-accepted paintings.

This exhibition and catalogue of Goya's work illustrate the practice of connoisseurship at the Metropolitan, and in them the visitor and reader will find an approach that stresses issues of discernment and quality and puts a premium on the direct examination of the works of art. A high point of the exhibition is the unique opportunity offered us by the generosity of an anonymous collector to compare his *Majas on a Balcony,* an unquestioned masterpiece by Goya, with the Metropolitan's version from the Havemeyer collection, a famous picture about whose authorship questions have recently been raised.

The exhibition is made possible by financial support from Goya Foods, and we greatly appreciate their backing for this endeavor.

Finally, I am grateful to Colta Ives and Susan Stein for their valuable contributions to this exhibition and catalogue, which place our collection in the context of Goya's career and of the Museum's history.

Philippe de Montebello
Director

Preface and Acknowledgments

This publication is intended to serve as an introduction to the Metropolitan Museum's extensive holdings of paintings, drawings, and prints by Francisco de Goya y Lucientes (1746–1828), which will be placed on view in their entirety for the first time this fall. Although the collection includes some of the Museum's best-known and beloved paintings—from the "little boy in red" to the now-contested *Majas on a Balcony*—its real strength lies in its relatively hidden assets, the fragile works on paper that present the full sweep of the artist's prolific and many-sided genius. Indeed, the Museum's fine drawings and prints by Goya permit us to document the range and power of his production in the chronological format of the exhibition, and also in the survey of his career, which is the first of this publication's essays. The second essay presents a history of the Museum's activity as a collector of Goya's work and helps to explain the relative strengths and weaknesses of our holdings of paintings, drawings, and prints, each of these three distinct areas having been formed under different circumstances.

As the collection has evolved, so too have notions of Goya's achievement. Insofar as this historical perspective provides a framework for understanding current reappraisals of Goya's art, it also reveals the Museum's long-standing commitment to the artist, one that makes this exhibition appropriate among celebrations of the 125th anniversary of this institution's founding.

The idea for the project was initiated earlier this year by Director Philippe de Montebello. It may be seen as the natural outgrowth of inquiries raised during preparations for the relatively recent exhibitions "Goya and the Spirit of Enlightenment" (1989) and "Splendid Legacy: The Havemeyer Collection" (1993).

Aside from the pleasure and general appreciation gained in viewing many works by a single great artist, such efforts allow a close examination of our holdings in light of new research. The degree of advancement in our knowledge and understanding of an artist's oeuvre necessarily varies, and development in some cases may yet be in nascent stages. This is true with Goya, a towering but enigmatic figure, whose most important paintings remain, largely, in Spain.

Goya's reputation traveled far and wide on the wings of his published graphic works, which were multiple, portable, and easily acquired; this accounts for their fame. On the other hand, the limited availability of authentic paintings by Goya outside his native land has made the collecting of his oils much more problematic and, as is pointed out in the pages that follow, fraught with controversy.

In recent years, Goya's art has come under rigorous scrutiny. Owing to research on all fronts—technical, historical, archival, and iconographical—new information has come to light that has challenged former assumptions and prompted reassessment. Even famous, long-accepted works, like the Museum's *Majas on a Balcony,* have been cast into doubt, and opinions regarding the authenticity of other paintings fluctuate, seemingly, from day to day. It is the aim of

our exhibition to throw open the doors to new insights and revisions as we survey a cross section of Goya's splendidly ingenious production.

The knowledge and expertise of scholars long devoted to the study of Goya have provided the essential structure and content for the realization of this project. Great appreciation is owed first of all to Gary Tinterow, Englehard Curator of European Paintings, and Hubert von Sonnenburg, Sherman Fairchild Chairman of Paintings Conservation, who generously and personably contributed the benefits of their long and intense experience. Juliet Wilson-Bareau, Priscilla Muller, and Janis Tomlinson also provided significant assistance, by way of their excellent writings and, collegially, at first hand.

Most helpful in the preparation of this publication and deserving of our thanks are Jenny Wilker, who assembled the print section of the checklist;

Anne M. P. Norton, who contributed her insights and extensive knowledge of Goya's paintings; and Margaret Aspinwall, Senior Editor, and other members of the office of John P. O'Neill, Editor in Chief. Patrick Seymour is responsible for the handsome design of the publication. Works on paper were conserved by Helen K. Otis and Margaret Lawson; David del Gaizo and Calvin D. Brown attractively mounted and framed them for display. For their design and installation of the exhibition, we are indebted particularly to Jeffrey L. Daly, Daniel Kershaw, Linda M. Sylling, Constance Norkin, and Zack Zanolli.

Colta Ives
Curator, Drawings and Prints

Susan Alyson Stein
Assistant Curator, European Paintings

The Artist and His Works

Colta Ives

Goya covered a greater range of subject matter than any other painter of equal power. He depicted Spain from court to pot-house, from church to bull ring. He gaily decorated the bedroom of the crown prince, covered the walls of churches, and, shirking nothing, was the first and the last great painter of war. From dignity to bestiality, from sanity to madness, from proud confidence to abject fear, no human predicament was beyond his experience or escaped his portrayal. Forging new and personal techniques to meet the exigencies of his ideas, he colored the vision of the succeeding century. —William M. Ivins, Jr.[1]

Goya's art has always been difficult to define. As witness to the dawn of the modern era, it straddles two centuries and is marked by the traumas of public revolution and private torment.

Appointed painter to Spain's Bourbon royalty in 1789, only three months before the storming of the French Bastille, Goya served the Madrid court for over forty years. He was the last great artist in the employ of European kings as an official decorator and portraitist, and the first of his profession to depict with profound sympathy and alarming realism the often senseless and ill-fated lives of ordinary people.

Goya created nearly 1,800 images by painting on plaster, canvas, ivory, and tin; by drawing in crayon, ink, and chalk on paper and the smooth surfaces of lithographic stones; and by etching lines and grainy aquatint into copper printing plates. In 1756, at the

FIGURE I

Don Manuel Osorio Manrique de Zuñiga. Oil on canvas, 50 x 40 in. (127 x 101.6 cm). THE JULES BACHE COLLECTION, 1949 (49.7.41)

age of ten, he helped his father gild the cabinet for the organ in the Calahorra Cathedral. While still in his twenties, he gained his first important paintings commission to decorate the ceiling of the choir in the cathedral of Santa María del Pilar, an assignment that brought him renown throughout his native region of Zaragoza. Not long afterward doors were opened for him to the court at Madrid by his teacher (and the brother of his then-recent bride), Francisco Bayeu, who helped him to secure work at the Royal Tapestry Factory. Indeed, it was Goya's spirited production of painted designs for tapestries to enliven the living quarters of the royal palaces of the Pardo and the Escorial that first endeared him to Crown Prince Carlos and Princess María Luisa, the future king and queen, who were to become his most active and influential patrons.

In more than sixty room-sized tapestry cartoons painted between 1775 and 1792, Goya repeatedly demonstrated his ingenuity at staging picturesque spectacles, particularly ones that glorified the popular pastimes of young and old, rich and poor. Among these is a series of tableaux recollecting the colorful

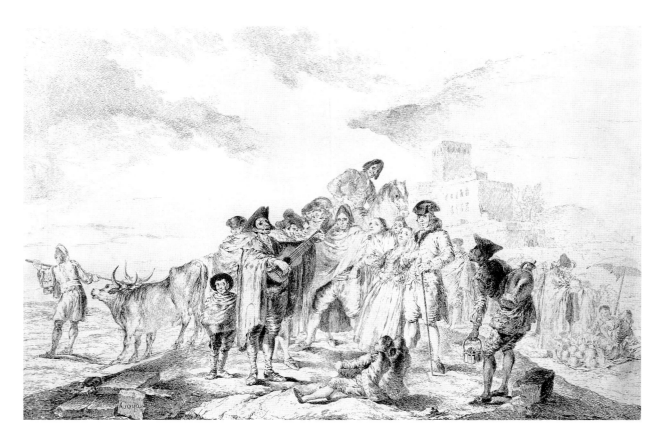

FIGURE 2

The Blind Guitarist, 1778. Etching; working proof; 395 x 570 mm.
PURCHASE, ROGERS FUND AND JACOB H. SCHIFF BEQUEST, 1922 (22.63.29)

sights and sounds of the annual fair at Madrid, including a blind guitarist who serenades a rapt assembly of cloaked majos, children, waistcoated gentlemen, and an itinerant water seller. So extraordinarily complex was this large composition that the tapestry weavers evidently complained and Goya had to make changes. He took the trouble, however, to preserve his original design by first copying it in a large copperplate etching (fig. 2).

Although printmaking was far from common practice among artists in Spain, Goya seems to have felt an affinity for the graphic arts and probably envisioned his career handsomely enlarged by the distribution of his own printed pictures. For four years, in the Zaragoza studio of the painter José Luzán, he had studied the principles of drawing by copying prints. Furthermore, his youthful sojourn in Rome during 1770–71 put him in direct contact with a thriving Italian production, then distinguished by the free-style etchings of Piranesi and the Tiepolos, who came to

Madrid in 1762 to embellish the king's palace. These artists' prints found their way into Goya's own art collection, and their influence on his work is evident, as is that of other eighteenth-century painter-printmakers including Fragonard, Hogarth, and the little-known Genoese Giovanni David.

To a remarkable degree, Goya's art was his own invention. Only his fellow countryman Velázquez might have claimed credit for his achievement. In 1778 Goya created a group of etchings reproducing the palace collection of Velázquez's portraits of royalty and their retinues, among them the most admired of his grand and flamboyant canvases, *Las Meninas* (fig. 3). In this seemingly surreptitious portrait, the Infanta Margarita Teresa, coddled by her nannies, is presented from the viewpoint of her royal parents, who pose before the painter. (The couple is reflected in the back-wall mirror.) The spatial and tonal complexities of Velázquez's magnificent large picture ultimately proved daunting to Goya, who tried to approximate

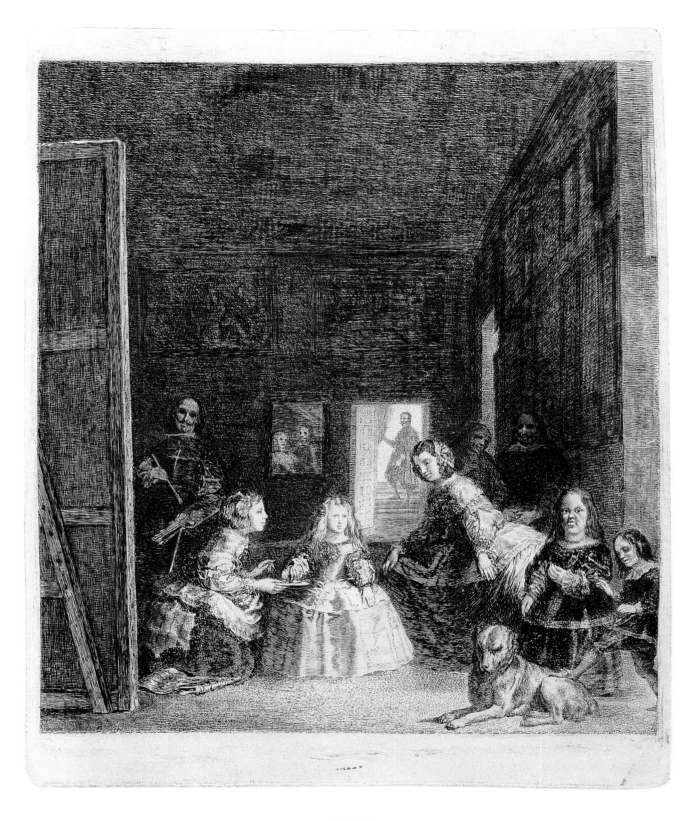

FIGURE 3

Las Meninas, after Velázquez, ca. 1778. Etching, drypoint, burin, roulette, and aquatint;
working proof of the third state; 405 x 325 mm.
PROMISED GIFT OF DERALD H. AND JANET RUTTENBERG

13

them on a much smaller scale and in black and white. Without the color and substance of oil paint to aid in the definition of so cavernous a room, illuminated by brightness entering through front windows and an open doorway in back, the composition's middle ground collapsed. Goya captured admirably the delicacy of the wistful infanta's features and her finery, ably characterizing her handmaidens and other colorful members of her entourage, but the vast recesses of the gallery-turned-painter's-studio defied description.

After worrying over his etching plate with successive lines and layers of aquatint in an attempt to achieve the proper depths of black, Goya finally abandoned the overworked plate; only a handful of proofs survive to track his intensive efforts.[2] In all, Goya had intended to produce twenty-one etchings after Velázquez, but only eleven were published.

Startlingly, in the midst of Goya's energetic courtship of both the Royal Academy of San Fernando and the throne, there emerges his electrifying image of *The Garroted Man* (fig. 4), an etching he printed in a very small edition. Officialdom could hardly have been expected to admire this brutal scene, even though the form of punishment depicted (a neck screw worked through an iron collar) was reserved for condemned criminals of noble lineage. If Goya was reporting a specific execution, he did so with unblinking empathy, registering the victim's anguish in zigzag lines and, in the Museum's unique working proof, veiled with a distressing haze of blue ink. Prescient of the tragic events and dreadful imaginings Goya was yet to experience, *The Garroted Man* occupies a dark corner of his early work.

As he continued to satisfy commissions for the adornment of palaces and churches by injecting fresh life into relatively conventional pictorial subjects, Goya became more and more actively engaged in painting portraits of officials and aristocrats to whom he was introduced by his activity within the royal circle. Indeed, portraiture became the center post of his nearly sixty year long career, and the regular focus of his rapt study of the characteristic traits of specific individuals, in contrast to his probing analyses of the rituals of society at large and its behavioral extremes.

Among the first of Goya's important private patrons were executives of Madrid's leading bank, today's Banco de España, five of whom Goya painted in official portraits between 1785 and 1788. One of the directors, the count of Altamira, further commissioned the artist to paint his wife and children. Striking an admirable balance between elegant formality and familiarity, Goya portrayed the *Countess of Altamira and Her Daughter* (fig. 5) in a confection of pastels, detailing their doll-like features and the luxury of their furnishings and dress with the utmost sensitivity.

The portrait of the count and countess's third son, *Don Manuel Osorio* (fig. 1), is finely differentiated from the rococo presentation of his mother and sister. Outfitted in a red jumpsuit, he is caught in the midst of play with a pet magpie (that picks up the painter's calling card in its beak), a fancy cage of finches, and three wide-eyed cats. The potential tragedy envisioned in this encounter of captive birds and felines has been interpreted as an emblematic reference to the fleeting nature of innocence and youth. Drama of this nature anticipates the allegorical content of Goya's etchings the *Caprichos*. The artist's affection for his own four sons and his daughter would certainly have colored such portraits. In 1789, around the time this one was painted, Goya wrote to his friend Martín Zapater with proud news of his youngest child, Javier, whose age differed from Don Manuel's by only a few months, "I have a son of four, who is so beautiful that people look at him in the street in Madrid."[3] (Javier was the only one of his offspring to survive childhood.)

Although he had obtained in 1786 the salaried position of Painter to the King, it was not until April of 1789, after Carlos IV assumed the throne, that Goya was promoted to Court Painter. His elevation

FIGURE 4

The Garroted Man, ca. 1778–80.
Etching printed in blue ink; working proof; 330 x 210 mm.
ROGERS FUND, 1920 (20.22)

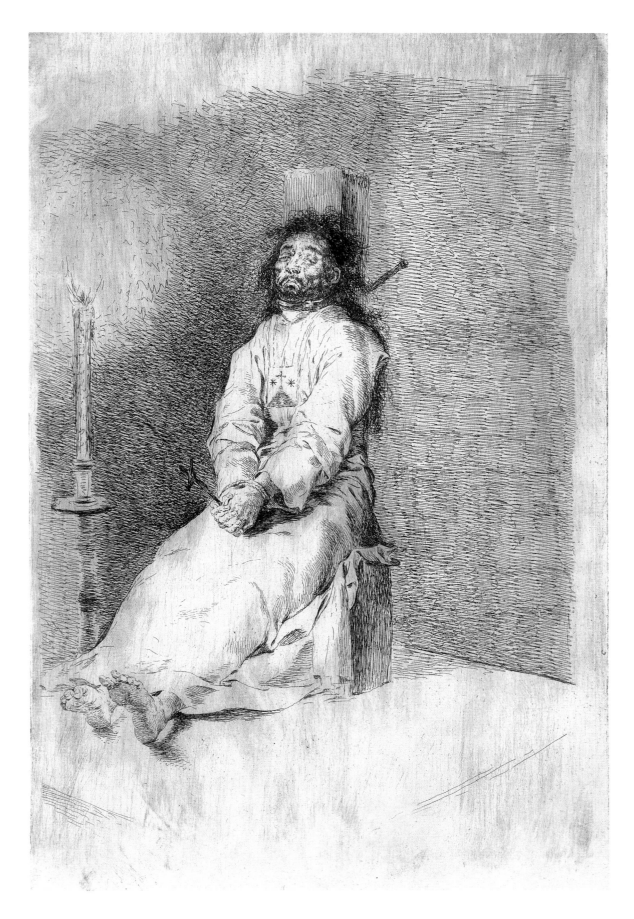

in the ranks of royalty could hardly have been more poorly timed, however, for in July the Bastille in Paris was overwhelmed, and the Bourbon monarchy in Madrid soon felt repercussions, as did Goya himself. Louis XVI sent his cousin Carlos IV a desperate appeal for refuge, but in January 1793 he was guillotined, and France declared war on Spain. During the political upheavals, several of Goya's protectors at court fell from grace, and although he continued to paint portraits and grand interior designs, his career was significantly disrupted. Amid all this turmoil, Goya was beset by illness, first in 1790, after the death of his eldest son, Eusebio Ramón, and again, more gravely, not long after he completed a superbly sympathetic portrait of his friend Sebastián Martínez (fig. 23) late in 1792. Martínez, a merchant whose home was in the southern port of Cádiz, sheltered the painter during his recuperation. However, from the fevered "ravings" and bouts of depression that attended a virulent infection (probably the result of lead poisoning), Goya emerged, months later, totally and incurably deaf.

The group of small paintings on sheets of tin that Goya submitted to the Royal Academy in January 1794 reveal an art profoundly transformed by the ordeal of illness, but miraculously reinvigorated. As if to announce his renewed creative power, the artist ventured beyond the tried and true and, in scenes peopled with thieves, murderers, and madmen, like the *Yard with Lunatics* (Meadows Museum, Dallas), Goya unlocked the door to a world of depravity. Seeming to wage his own personal revolution against the constraining authority of the academy, privileged patronage, and long-held artistic tradition, he plunged into the boundless realms of imagination.

Exercising greater freedom in his brushwork, as well as in his imagery, Goya challenged his hand still further by taking up a vigorous practice of the graphic arts. In his deafness he must have adopted the habit of carrying paper and writing tools at all times, if only

to offer to others as an alternative to speech. Unable to hear his own voice he, too, may have taken to putting his words into writing. Thus it must be more than coincidental that his first album of drawings, providing pictorial commentary of his concerns, was realized in 1796, three years into his silence, and marks the start of an immense graphic production numbering close to a thousand drawings and nearly three hundred etchings and lithographs.

Unlike the workaday sketchbooks artists fill haphazardly with fragmented memoranda of things seen or studies preparatory to some formal project, each of the eight albums Goya charged with ink- and chalk-drawn figures appears to have been planned in advance as a coherent whole. Each might have been conceived as a conversation piece, complete with captions, to pass among friends or enlightened acquaintances. Virtually every sheet contains a vivid representation of one or more figures engaged in an activity that is pitched to extremes of absurdity, rather like the broad and often coarse caricatures of the contemporary English satirists Rowlandson and Gillray.

The drawings in Goya's albums began to be dispersed by his son and grandson in the 1840s, some years after the artist died, but because he had numbered each page, and the stylistic and physical characteristics of each group are distinct, it has been possible to reconstruct their contents. One of the earliest of the drawing books, the "Madrid Album" (Album B), dates from 1796–97, about the time Goya painted the monumental portraits that celebrate Spain's illustrious, self-possessed beauty, the duchess of Alba. Its pages, filled with wash drawings deftly sketched with the point of a brush, chart the artist's discovery of his own quirky vision and the decided but rumpled

FIGURE 5

The Countess of Altamira and Her Daughter. Oil on canvas, 76½ x 45¼ in. (194.3 x 114.9 cm).
ROBERT LEHMAN COLLECTION, 1975 (1975.1.148)

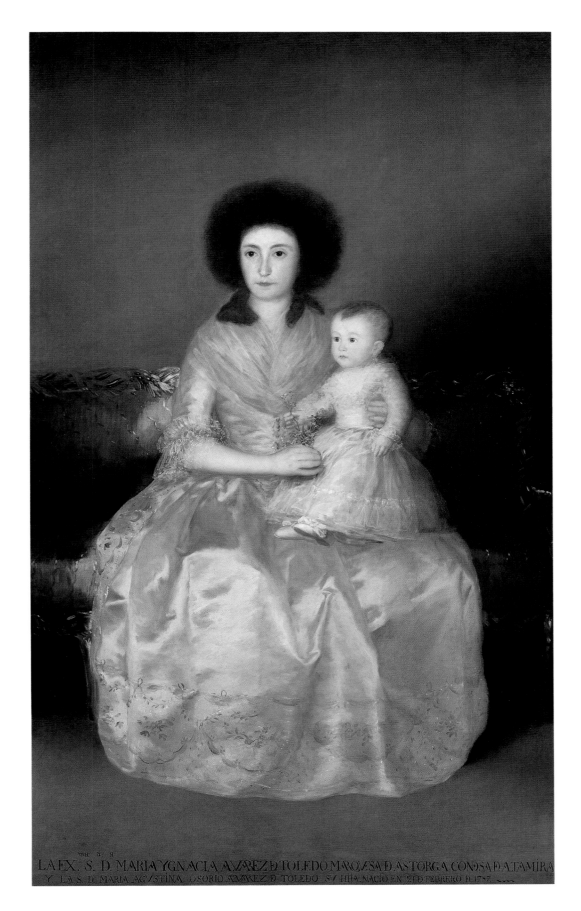

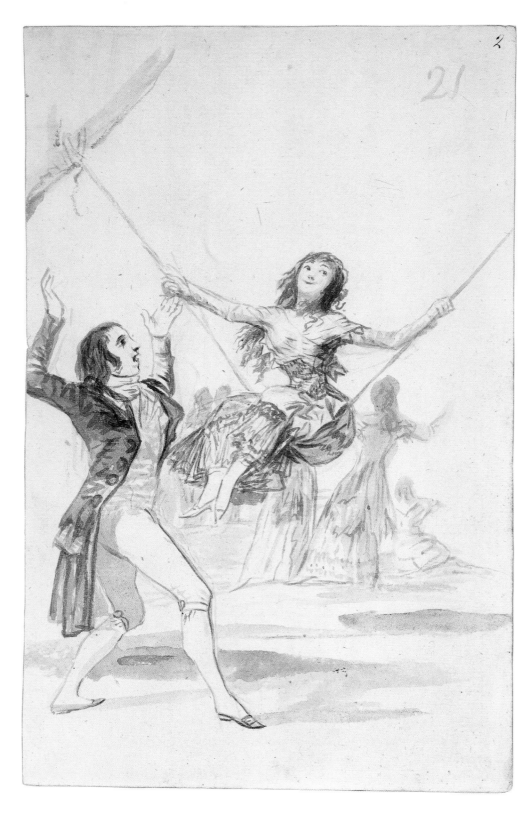

FIGURE 6

The Swing. Album B, page 21, 1796–97. Brush and gray wash; 237 x 146 mm.

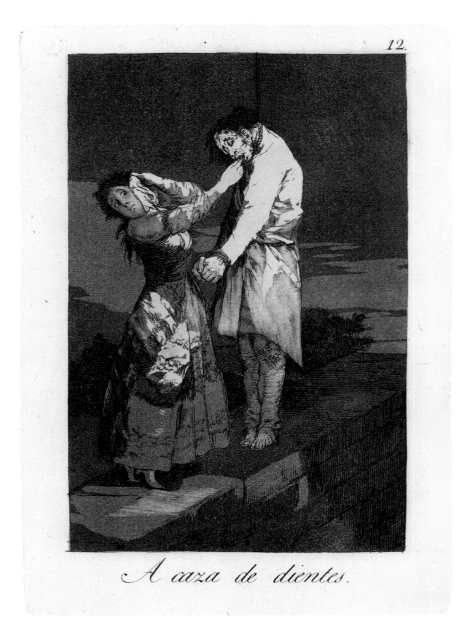

FIGURE 7

Out Hunting for Teeth, plate 12,
Caprichos, first edition, 1799.
Etching, burnished aquatint, and
burin; 215 x 150 mm.
GIFT OF M. KNOEDLER & CO.,
1918 (18.64)

draftsmanship that is like no other's. Some vignettes, like *The Swing* (fig. 6), with its dreamily smiling maja and her enthusiastic suitor, glance backward at Goya's playful decorations for palatial interiors, while others look forward to the more sobering, often ridiculous grotesques of the etched *Caprichos* (fig. 7), on which he appears to have been working simultaneously.

The groundwork for the emblematic pictorialization of human weakness and irrationality in the eighty etchings of the *Caprichos* was well laid in the ninety-four drawings of Album B (sixteen of which are now in the Museum's collection). There are staged manifestations of superstitious beliefs, like the imagined power of a hanged man's teeth (see fig. 7), and such ludicrous spectacles as that of jackasses acting like gentlemen (to imply that the opposite is generally the rule). These images combine striking candor with a bold, free handling of the graphic media, made all the more remarkable by an unexpected delicacy in all details and sharp discipline in the compression of their compositions. The admirable balance between light and dark, tone and line, so readily apparent in the

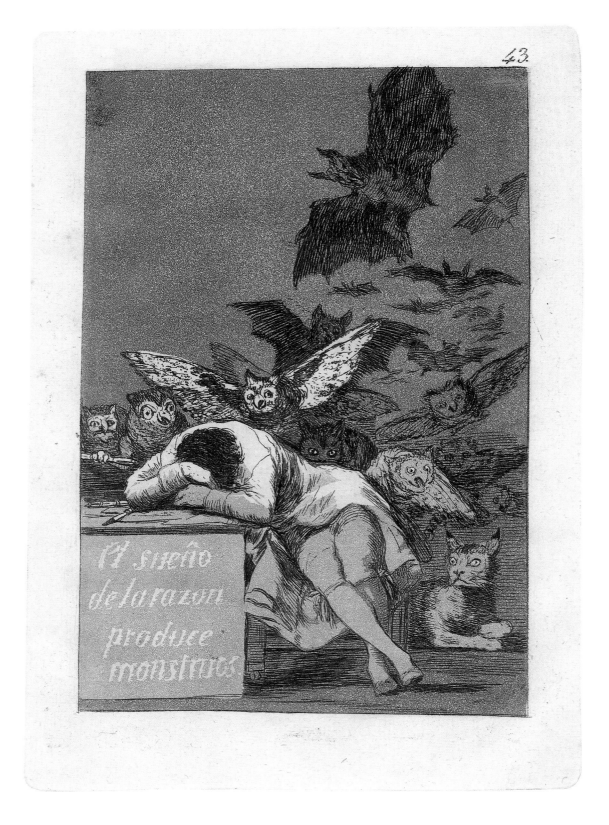

FIGURE 8

The Sleep of Reason Produces Monsters, plate 43, *Caprichos,* first edition, 1799. Etching and aquatint; 215 x 150 mm.

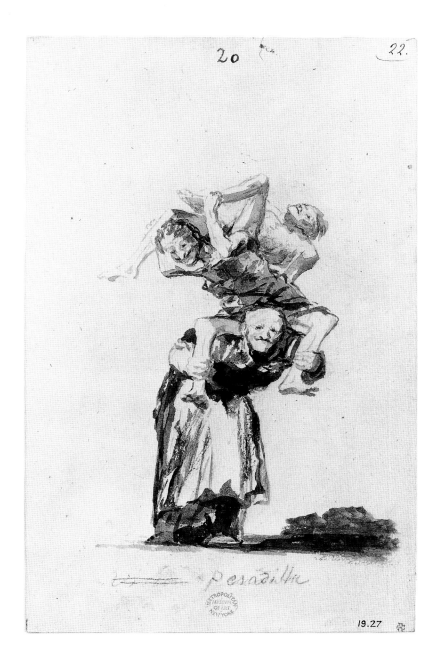

Nightmare. Album D, page 20, 1801–3.
Brush with black ink and gray wash;
233 x 144 mm.
ROGERS FUND, 1919 (19.27)

drawings, became a complex feat in the etchings, where shadows and veils of gloom were realized in calculated dustings of grainy aquatint. Thus Goya achieved a higher plane of accomplishment, artistically and technically, than any social commentator before his time.

At the outset, Goya planned to begin his suite with a series of *sueños* and to open with the most profoundly personal of his "dreams," *The Sleep of Reason Produces Monsters* (fig. 8). The image, which has the self-searching poignancy of another engraved masterpiece, Albrecht Dürer's *Melencolia I,* verges likewise on the autobiographical, showing the artist overwhelmed by the torments of his own mind. Having survived the still relatively recent hallucinatory fevers that brought him near death, Goya could envision himself the anguished draftsman, besieged by diabolical night creatures and forced to succumb to the hideous darkness of the irrational. The artist's revelation of his own shadowy descent properly sets the stage for his extended pictorial indictment of society's lapses (although he later positioned his *sueños* sequence midway in the suite). As if to justify his strange insights, he asserted in his announced publication of the

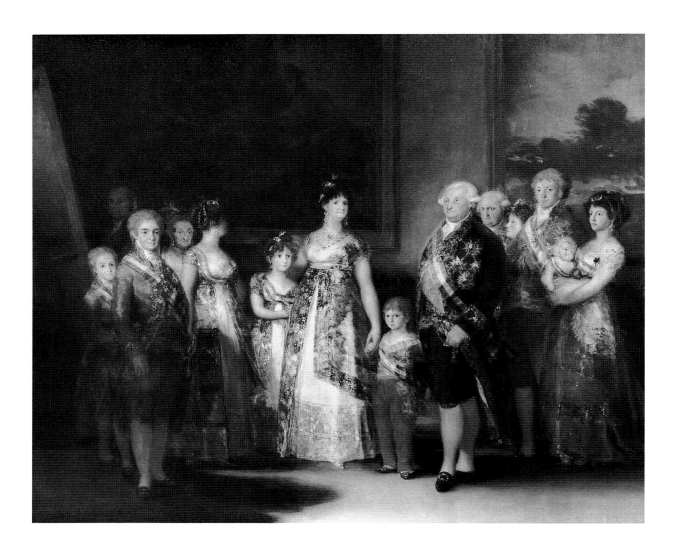

FIGURE 10

Family of Carlos IV, 1800–1801. Oil on canvas, 110¼ x 132¼ in. (280 x 336 cm).
MUSEO DEL PRADO, MADRID

Caprichos, "He who departs entirely from Nature will surely merit high esteem, since he has to put before the eyes of the public forms and poses which have existed previously in the darkness and confusion of an irrational mind, or one which is beset by uncontrolled passion."[4]

The monstrous visions that were given such vivid life in the drawings of Album B and in the etchings of the *Caprichos* continued to haunt Goya, as is evidenced by somewhat later wash drawings comprising the "Unfinished Album" (Album D), believed to have been executed between 1801 and 1803. The Metropolitan Museum owns three (and possibly four) of the twenty or so known pages of Album D which contain the contorted figures of madmen, hags, and witches, some reeling through the air, others staggering under the weight of their own wickedness, all of them cast into the irresolute space of a blank page. Among them is the grinning figure of a crone bent to her task of bearing two grotesque and unruly companions (fig. 9). First captioned by Goya, *Vision,* and later *Pesadilla* (Nightmare), to play on the word *pesar* (to weigh, or to be heavy), this is an exemplary illustration of the sort of "monsters" that might be produced by "the sleep of reason." Goya's vehement fantasies now found expression in a new flexibility of brushwork, seen throughout Album D, that entangled brittle lines with broad and heavy strokes.

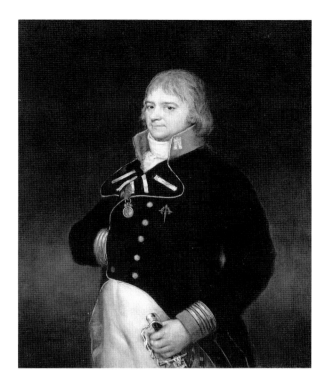

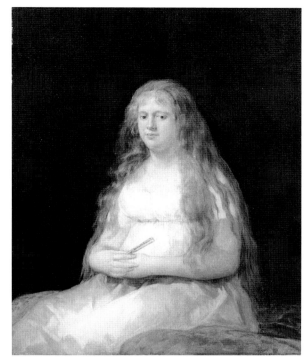

Far from withdrawing into isolation after his deafening illness of 1792–93, Goya demonstrated his regained vitality not only in ambitious graphic works, but also in a full schedule of religious commissions and portraiture assignments. Indeed the years from 1799 to 1808 mark the height of his professional career. He painted official portraits of the king and queen, at first stiffly standing (Carlos IV in hunting attire; María Luisa in black lace) and later, on horseback. On October 31, 1799, only a few months after publishing the *Caprichos,* Goya was promoted to First Court Painter and soon commenced portrait studies of several royal relatives resulting in the formal presentation of the entire, overdressed *Family of Carlos IV* (fig. 10). A tribute to the grandeur of Velázquez's royal portraits, Goya's ostentatious canvas is terribly impressive and may have served to assure a skittish populace of the solidity of the monarchy. Most extraordinary is the bald realism of the characterizations. Evidently the glassy-eyed relatives in jewel-encrusted silks recognized their own faces without truly seeing themselves.

Goya's uncompromising frankness marks also his pictures of patrons of the court. His pair of portraits of Don Ignacio Garcini and his wife, Doña Josefa Castilla Portugal de Garcini (figs. 11, 12), are rigorously unsentimental, and except for the fine tailoring of the colonel's uniform and his decorations (the red cross of the Order of Santiago was added, when awarded, two years later), there is scant material in them to seduce the eye. Doña Garcini was evidently pregnant at the time of the sitting, which could account for the informality of her confined-to-the-house hair and dress. Pink-cheeked (by Flemish descent) and painfully self-conscious, she guards her plump midsection apprehensively.[5]

Goya's regular practice of portraiture, as well as some profitable business contacts, made it possible for him to weather Spain's political tempest without severe financial distress. His clients among Madrid's

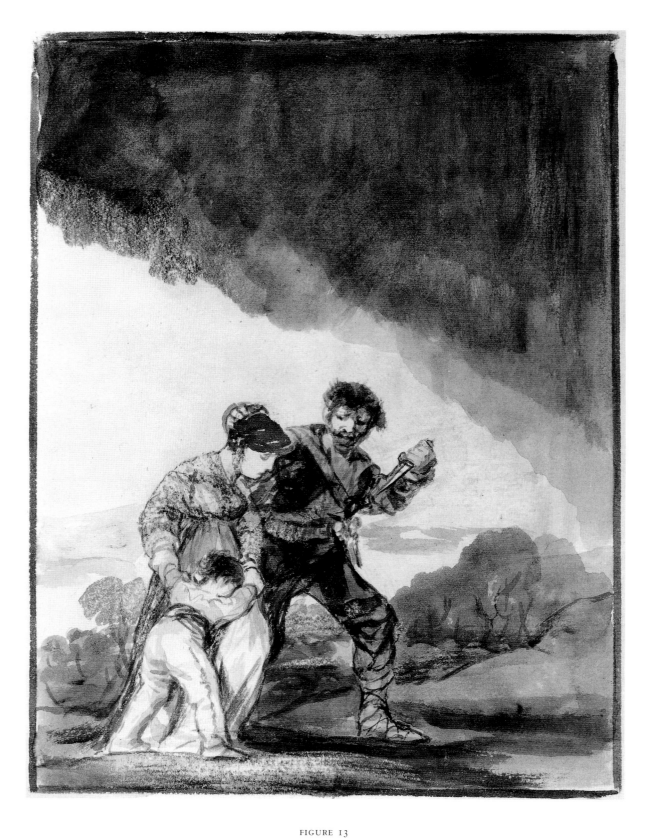

FIGURE 13

God Save Us from Such a Bitter Fate. Album E, page 41, 1806–17. Brush with black ink and wash; 268 x 188 mm.
HARRIS BRISBANE DICK FUND, 1935 (35.103.50)

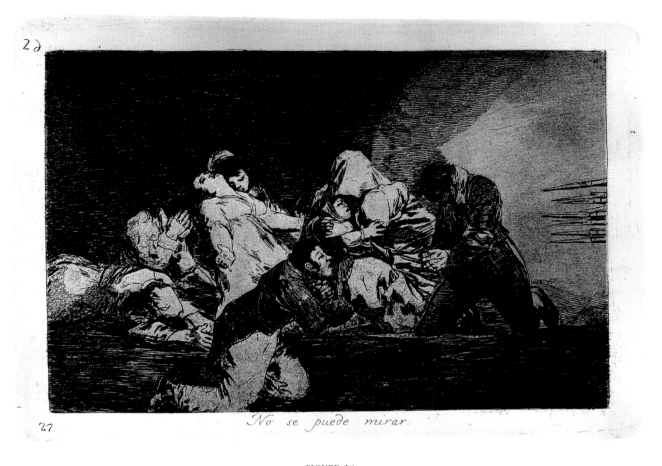

FIGURE 14

One Can't Look, plate 26, *Los Desastres de la Guerra,* 1810–15.
Etching, drypoint, burin, and burnished lavis; first edition, 1863; 145 x 210 mm.

expanding middle class also may have enlarged his view of life outside the confines of the royal court, while contributing to his professional stability and independence. Thus he could paint what he pleased.

In 1806 local broadsheets carried news of the dramatic capture of a bandit, El Maragato, who was disarmed and turned over to police by a monk. This heroic feat so intrigued Goya that he serialized it in six panels arranged like scenes in a filmstrip. As his first important effort to narrate specific current events, the Maragato series presents further evidence of the artist's concern with contemporary perils. The growing strength of his commitment to the often brutal reality of day-to-day life began to express itself also in his drawings. Among those associated with the "Black Border Album" (Album E) and variously dated from 1806 to 1817, none is so exquisitely realized as the scene on folio 41, in which we are made witness to a cutthroat's kidnapping of a young mother and child (fig. 13). The solemnity of the tiny procession that creeps from a sunlit meadow into the shadowy mouth of a cave commands our attention and sympathy on a scale that far outsizes the image. Not long afterward in an extended, tortuous series of etchings, the *Disasters of War* (fig. 14), Goya achieved just such a level of profoundly affecting tragedy again and again.

After Napoleon's invasion of Spain in 1807 and 1808 brought about the abdication of the Bourbon rulers, violent protests against the French erupted in Madrid. The uprising of May 2, 1808, marked the start of the armed Spanish resistance, which dragged on in guerrilla warfare until 1814. That first brave rebellion by the Spaniards and the ferocious retaliation by the French were memorialized at the end of the war in Goya's two dramatic renditions of the deadly attacks. During the years of the war, Goya vented his horror

and outrage at the atrocities committed in its behalf by soldiers and patriots gone mad in the craze of hand-to-hand combat.

In eighty small, compact images, each etched with acid on copper, Goya told the appalling truth. He aimed a high-power beam on hideous sights: guerrillas shot at close range; the ragged remains of mutilated corpses; and the emaciated victims of war's partner famine. Never before had a story of man's inhumanity to man been so compellingly told, every episode reported with the utmost compassion, the human form described with such keen honesty and pitying respect.

Goya probably estimated correctly that, once the conflict was ended, the Spanish people would have little appetite for anguished mementos of ruthlessness witnessed, reported, or imagined. Furthermore, it was a time of stern repression. Thus, aside from the proofs he made as he worked, Goya printed no other impressions of the *Disasters of War*. Not until 1863, thirty-five years after his death, was the first of seven posthumous editions of the *Disasters* published by Spain's Royal Academy, which in 1862 purchased all eighty etched copperplates.

The imagery of Goya's monumental *Giant* (fig. 15) undoubtedly arises from the grim wasteland of war. However, the enigma presented by the forceful and menacing superhuman (subhuman?) form beggars description. Goya sculpted the bulk of this crouching behemoth, a war god bathed in sun- or moonlight, by scraping lightness into his dark and coarsened plate— just as the masters of mezzotint did to approximate the tonal range of paintings. He must have had difficulty maintaining the fragile, velvety nap of the roughened plate, for only seven impressions of this haunting image survive.

The *Giant* can be compared to two paintings by Goya, each of which is more than twenty times its size: the *Colossus* (ca. 1808–12; Prado, Madrid), in which a monstrous figure strides through a landscape of terror-stricken fugitives; and *Saturn,* a cannibal god

devouring his offspring, painted by Goya on the walls of his country house the Quinta del Sordo (now in the Prado). All three of these works testify to Goya's apprehensive fascination with uncontrolled power. Of the three, the aquatint, by far the smallest in size, is perhaps the most monumental. In the bold simplicity of its conception, its near-Hellenistic grandeur, and kinship with the troubled musclemen of Michelangelo, Annibale Carracci, Giambattista Tiepolo, and Piranesi, this giant repulses as it attracts, inspires awe but threatens to crush.

Although canvas was scarce during the war years, 1808–14, Goya continued to paint, and with portrait commissions also in short supply, the artist returned to subjects of genre. But instead of the sweeping compositions of his tapestry designs, which were filled with figures and landscape meant simply to brighten a domestic interior, the subjects of Goya's paintings were now often intense conversation groups or single figures that might have leaped from the pages of his drawings albums or from the etchings of the *Caprichos*: street vendors and tradesmen, majas parading on balconies (see figs. 42, 43), and satirical allegories of alluring youth and grizzled old age. Like the etchings of the *Disasters of War,* in which he was simultaneously occupied, these paintings are works of astonishing originality wrought with finesse in unexpected proximity to crudeness.

Goya returned to his salaried position as Court Painter after Napoleon's abdication and the withdrawal of the French from Spain, but the restored King Ferdinand VII showed scant regard for his parents' favorite. The overturn of the constitution and the renewal of a corrupt collusion between church and state rankled liberals and sparked Goya to append to his *Disasters of War* fifteen etched *caprichos enfáticos* satirizing the destructive whims of tyranny. He had survived the initial palace purge, but in 1815 he was summoned before the Inquisition to answer obscenity charges in connection with two paintings of the former prime minister Godoy's mistress, the *Nude Maja*

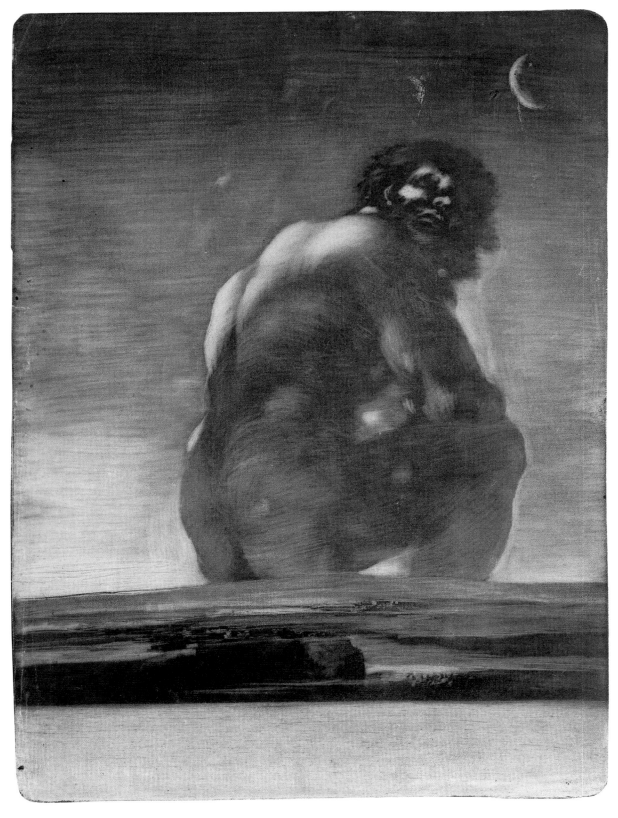

27

FIGURE 16

Soldiers Frightened by a Phantom, plate 2, *Disparates,* ca. 1816–17.
Etching, burnished aquatint, and drypoint; posthumous proof, ca. 1848; 245 x 350 mm.
ROGERS FUND, 1921 (21.54.2)

and the *Clothed Maja* (both now in the Prado). Apparently the issue was settled or charges dropped.

It was at this point that the tirelessly inventive Goya began work on a whole new series of prints, a set of imaginary scenes much larger and more ambitious in their compositional scheme than his *Caprichos* of 1799, but like them, fantastically critical of humanity's failings. Because these twenty-two *Disparates,* or "Follies," lack captions, we still grope for their meaning (as we yet continue to search for keys to the *Caprichos*). In the infinite space of their eerie night world irrational situations are seen to occur: people nest in trees, an elephant is taught from a book, a towering phantom stalks the battlefield (fig. 16), and men hang glide on borrowed wings. The overriding theme of man's gullibility is staged in superbly constructed scenes of such full dramatic substance that they might have been conceived as paintings. The wonder is that Goya failed to publish this group of prints, on which he may yet have been working shortly before his departure from Spain in 1824. The plates, which Goya left with his son, were printed in their first edition in 1864.

The drawings in Goya's "Sepia Album" (Album F) (see fig. 17) probably date close to the *Disparates.* The range of subjects in this group of eighty-eight sheets (surviving from a probable total of 106) is exceptionally broad, including beggars, hunters, acrobats and ice-skaters, gravediggers, mourners, duelers, and torturers—to name only a few. If anything, this panoply of figures confirms the deaf Goya's undiminished zeal for the sight of humankind in its myriad guises. The col-

FIGURE 17

A Nun Frightened by a Ghost. Album F, page 65, 1812–23. Brush and brown wash; 205 x 145 mm.
HARRIS BRISBANE DICK FUND, 1935 (35.103.37)

lected drawings are done in brush and brown wash; all are without captions. Few can be linked directly to others of Goya's works, although some like the *Nun Frightened by a Ghost* (fig. 17) attest to the artist's consistently anticlerical stance and raise the recurrent specter of uncontrolled, irrational power which he dreaded. The horrible, rubber-faced monk who proffers a totally unwanted serenade is close kin to the witches and demented pilgrims of the "black paintings" (ca. 1821–23) that Goya painted beside his ghastly *Saturn* in the murals of the Quinta del Sordo.

The short but violent attack of illness Goya suffered at the end of 1819 probably revived old demons and may have spawned new ones, but fantasy could not compete with the bite of reality. The portrait of Tiburcio Pérez (fig. 18), finished in 1820, vibrates with fellow feeling; much warmth must have been felt between the painter and his subject. One finds in this portrait an unabashed pleasure in worldly things. The architect's curly hair, his ruffled shirt, and casually grasped eyeglasses, all finely described, contribute to the charm of his bemused expression. The mood of this picture stands in sharp contrast to the morose "black paintings" done shortly afterward, although they share the same sooty palette and in both the oil paint was brushed on vigorously. Seventy-five-year-old Goya's control of his craft clearly was undiminished, and in independence and assurance continued to advance.

After dedicating fifty years to defining the Spanish character, Goya suffered the cruel fate of expatriation and was driven from Spain—ultimately by the absolutist regime of Ferdinand VII. In May 1824, on the pretext of taking the spring cures at Plombières in France, he was granted leave by the king and thereupon departed for Bordeaux. He returned from self-imposed exile only twice: in 1826, to petition for retirement, and in 1827, to visit his son and grandson. He died in Bordeaux in 1828; in 1901, his remains were brought to his homeland.

Goya's four-year career in France, passed between the ages of seventy-eight and eighty-two, might be the envy of any artist, so full was it in activity, novelty, and invention. Although, to the horror of his friend Leandro Fernández de Moratín, who had preceded him to Bordeaux, Goya "indeed arrived, deaf, old, clumsy, and weak, without a word of French, and without a valet (which no one needs more than he), [but] so happy and so anxious to try everything."[6] His drawings albums from this period reveal an artist still vitally concerned with the study of the character and behavior of people around him, and amid a few portrait commissions, he ventured to try his hand at relatively unfamiliar techniques, including painting miniatures on ivory and practicing lithography.

That Goya, an artist of extraordinary vision and depth, practiced with such intensity the technical intricacies of the graphic arts must be counted (as it is with Dürer, Rembrandt, and Degas) further proof of his creative genius. Having had little direct contact with the great centers of art in Europe, aside from the short trip made to Italy in 1770–71, he necessarily experimented on his own. His early command of the tonal process, aquatint, which he employed with unparalleled gusto to approximate the effects of his drawings' ink washes, gave vent to the same unprecedented skill and daring he applied quite late in life to the nascent art of lithography.

One of the first lithographic presses in Spain, which had been established in Madrid in 1819, prompted Goya to experiment in this still-new printing process. Discovering a skilled pressman, Gaulon, in Bordeaux, Goya now rose to a new technical challenge. Propping heavy blocks of limestone on his easel as if they were canvas, he drew on them dashing episodes from the bullring in celebration of Spain's national sport.

Less than a decade before, in an effort that might have been calculated to restore his countrymen's pride after the war, Goya had published a series of thirty-three etchings tracing the history of the bullfight from the time of the Moors' conquest of Spain up to his own day. In these focused images the maneuvers and feats of skilled individuals displayed their courageous

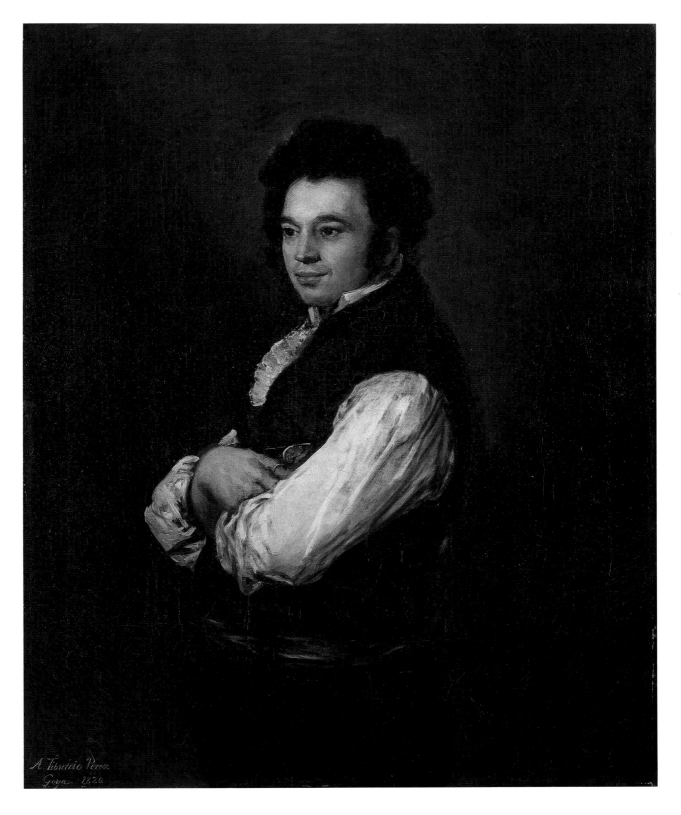

FIGURE 18

Don Tiburcio Pérez y Cuervo, the Architect, 1820. Oil on canvas, 40¼ x 32 in. (102.2 x 81.3 cm).
THEODORE M. DAVIS COLLECTION, BEQUEST OF THEODORE M. DAVIS, 1915 (30.95.242)

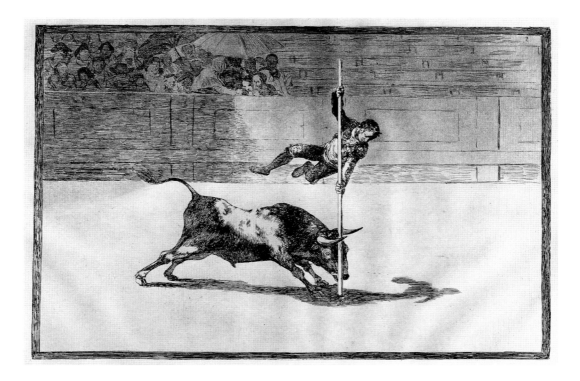

FIGURE 19

The Agility and Audacity of Juanito Apiñani in the [Ring] at Madrid, plate 20, *Tauromaquia,* first edition, 1816.

Etching and aquatint; 245 x 355 mm.

ROGERS FUND, 1921 (21.19.20)

daring (see fig. 19). But they are like snapshots as compared to the cinematic excitement of the four large lithographs now called the "Bulls of Bordeaux" (fig. 20). In both series of prints, one discerns Goya's shutter-speed grasp of a man's or an animal's stopped motion years before the same could be accomplished by the camera.

The unbridled vigor and enthusiasm with which Goya approached the novel experience of drawing with a greasy crayon on a slab of stone brings to mind the erratic activity of the corrida itself, with its false starts and near misses, passages of calm followed by gripping action. His varied manipulation of his tools, both blunt and sharp, intensified the drama.

In works such as these Goya delivered the most powerful announcements of the nineteenth century in black and white, and gave direction to the concerns of

art in the twentieth century. His *Caprichos* were the first of his works to infiltrate France, where the boldness of his realism combined with romantic fantasy took root. It reemerged in the darkened turbulence of Delacroix's paintings and prints, as it did somewhat later in the restrained simplicity of Manet's. Goya's etchings and lithographs have been the stock of artists' collections from their first printing to the present day.

The public and private upheavals Goya endured contributed the force of raw emotion to his art and shaped its oddly rugged outlines. His work holds us in thrall with the enormity of its humanism and the majesty of its artistry, even as this genius is placed in the service of deranged visions. Because he felt so deeply our common plight and could express without flinching its awful complexity, his art endures and continues to astound.

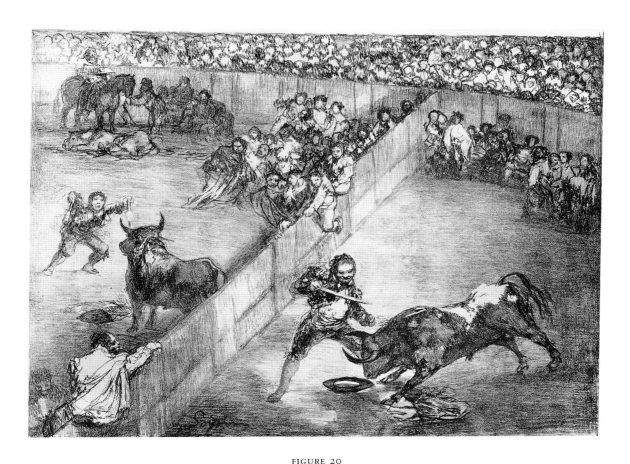

FIGURE 20

The Divided Ring, 1825. Lithograph; 300 x 415 mm. ROGERS FUND, 1920 (20.60.4)

1. William M. Ivins, Jr., in *Francisco Goya: His Paintings, Drawings and Prints,* exh. cat., MMA (New York, 1936), p. 4.

2. Goya made a final attempt to salvage his work by printing the fourth and last state of his overbitten plate in red ink on the verso of this black ink impression of the third state. Two other double-sided impressions printed in black and red are in Berlin (Kupferstich Kabinett) and Madrid (private collection). The only other impressions of the etchings known are in Paris (Petit Palais), Madrid (Biblioteca Nacional), London (British Museum), and Boston (Museum of Fine Arts). See Eleanor A. Sayre and the Department of Prints and Drawings, *The Changing Image: Prints by Francisco Goya* (Boston, 1974), pp. 49–50; and H. 17.

3. Goya, letter to Zapater, 1789, quoted from Jeannine Baticle, *Goya: Painter of Terrible Splendor* (New York, 1984), p. 61.

4. Quoted from Nigel Glendinning, *Goya and His Critics* (New Haven and London, 1977), p. 49.

5. Recent archival research indicates that Doña Garcini's mother was of Flemish origin, her maiden name being Josefa Castilla Portugal y Wanasbrok. Although her birth date remains unknown, records indicate a death date of about 1850. Janis Tomlinson kindly referred me to Nigel Glendinning, *Goya: La década de los Caprichos,* Real Academia de Bellas Artes de San Fernando (Madrid, 1992), p. 132. I am grateful to Professor Glendinning for providing a copy of the relevant article, José Valverde Madrid, "Cuatro retratos goyescos de la sociedad madrileña," *Anales del Instituto de estudios madrileños* 30 (1991), pp. 23–36.

6. Quoted from Gary Tinterow, "Chronology," in *Goya and the Spirit of Enlightenment* (Boston, 1989), p. 402.

A History of the Collection

Susan Alyson Stein

The Metropolitan Museum "finds itself in the enviable position of being able to arrange, mainly from its own collections, a truly imposing 'one-man show' of a major figure in the history of art—Francisco Goya." This quote was not furnished by Philippe de Montebello or taken from a press release for the current exhibition. It was written in 1936, by then-Director Herbert E. Winlock, at the time of the Museum's first such retrospective, "Francisco Goya: His Paintings, Drawings and Prints."[1]

Today the Metropolitan can boast an impressive group of paintings, a staggering array of figure drawings in ink, brush, and red chalk, which is second only to that of the Prado in Madrid, and "an exceptionally rich and complete collection of prints [by Goya] from every period and in various techniques."[2] In 1936 the Museum could make precisely the same claim.

Sixty years ago the Museum revealed the wealth of its Goya holdings for the first time. Since then the paintings collection has nearly doubled in size, thanks to the continued generosity of donors. Changes in the perception and evaluation of Goya's genius have, however, made for a different equation, reducing by half—from sixteen to seven—the total number of canvases now considered authentic. Today our collection is richer than it once was because of the paintings that have been added to the galleries, but it is perhaps no more impressive: after all, sixty years ago our masterpieces had yet to become "fool's gold."

Whereas the paintings collection has changed fairly dramatically since 1936, the collections of drawings and prints by Goya have not. The drawings collection is virtually the result of a single remarkable purchase: a group of fifty drawings bought in 1935. Overnight, our holdings grew from one to fifty-one drawings; today there are fifty-four. The collection of some three hundred prints, distinguished for its comprehensive range and for its depth, was assembled in two decades, from 1916 to 1936, under the aegis of one remarkable curator, William M. Ivins, Jr. Indeed, by 1936, the collection was so fine in quality, extensive in scope, and complete for the monumental print cycles that, save a few rare working proofs added later, nearly all subsequent donations have duplicated images already represented.

The paintings collection does not betray a similar initiative, nor is its history, which spans over a century, so narrowly circumscribed in time. Serendipity played a much larger role in shaping the collection, since gifts, as opposed to judicious purchases, account for all but two of the paintings that comprise our present holdings. If ultimately this collection is the least satisfactory assemblage, it is also true that it is the result of a quite different set of historical circumstances.

The events and individuals that contributed to the Museum's "enviable" collections of paintings, drawings, and prints by Francisco de Goya y Lucientes is

the subject of this study. In chronicling how these holdings have evolved from the nineteenth century to the present day, every effort has been made to let the voices from the past tell much of this story themselves.

It may be said that Goya has always been represented on the walls of the Metropolitan Museum, even if miserably at first, and in fact, even before the walls of the Central Park building had been erected. In 1871, the Museum acquired its first "Goya," a painting known as *A Jewess of Tangiers* (fig. 21). It was part of the bold purchase of 174 old master paintings, "which, when offered for sale at the breaking out of the [Franco-Prussian] war of 1870, were bought entire by the agents of the Museum."[3] This group, which initiated the Museum's collection, was composed largely of seventeenth-century Dutch and Flemish pictures, but there were a dozen or so examples from other schools, including one noted by American writer Henry James, by "the comparatively modern Spaniard, Goya." James was one of the first six thousand visitors

to see the collection on display in 1872 in quarters leased at a former dancing academy at 681 Fifth Avenue. He found this "sketch, by a cunning hand, of a doll-like damsel, bundled up in stiff brocade and hung about with jewels," to be "slight but salient."[4] In the Museum's first *Catalogue of Pictures of Old Masters,* the "Jewess of Tangiers by Goya" is described simply as a "picture in the first manner of the celebrated painter of Charles IV, [that] has been somewhat restored."[5] A minor effort in poor condition, the painting was virtually ignored for the next century: for the first fifty years that it hung in our galleries, and for the next fifty that it spent in storage.

The Museum's first "Goya," like its first "Brueghel" or its first "Van der Weyden," was nothing of the sort. Even in 1872, Museum trustees realized that "there are certain pictures in the collection which are not wholly adequate as examples of their authors," and that there are "perhaps a half dozen of pictures which at some future time may be sold or exchanged for other works of art." In the end some two-thirds of

the original collection, owing to the rigors of scholar-ship, to the qualitative growth of our holdings, and to changes in taste, have been deaccessioned, including the "Goya," which was sold at auction for a few hundred dollars in 1979 as a work by an unknown Spanish nineteenth-century painter. Nonetheless the 1871 purchase did include many paintings—by Guardi, Jordaens, Oudry, Poussin, Tiepolo, and others—that have continued to be an integral part of our galleries.

In 1871 nearly any unsigned portrait that was datable to Goya's career (and here the perimeters are broad, since he was productive for six decades, from the 1770s to 1820s), that was romantic in character, painterly in technique, and included some prop like a mantilla or a fan could have been readily accepted as a Goya. His paintings were virtually unknown outside Spain. Elsewhere in European museums, only the Louvre, which had to start from scratch after the sale of Louis-Philippe's collection in 1853, offered a first-hand glimpse of Goya's paintings in two portraits acquired in the 1860s. In the United States there were no points of comparison; it was not until 1897, with the pioneering acquisitions of Louisine and H. O. Havemeyer, that the first works by Goya came to this country. This date roughly coincides with the first English publications devoted exclusively to Goya's art,

for in 1871 less than a handful of monographs (three French, one Spanish), contributing a total of about fifty illustrations, had been published. Insofar as other reproductions existed in various reference and travel books as well as periodicals, these black-and-white images paled in comparison to the more colorful and lasting images created by prose.[6] In the literature, Goya emerges foremost as a biting satirist with a burin, yet also as a kind of swashbuckler with a brush, or rather, as critic Théophile Gautier perpetuated, "with sponges, brooms, rags, or whatever came to hand."[7]

Knowledge of Goya the painter lagged far behind that of Goya the etcher. Since the early nineteenth century, the *Caprichos* had captured the imagination of Romantic artists and writers, inspiring sketches by Delacroix and sonnets by Baudelaire. By mid-century, not only were there several facsimile editions available of the set of eighty prints that had held sway over critics' writings, but there existed a complete set of oil forgeries as well. Laurent Mathéron, in the very first monograph on Goya published in 1858, devoted a paragraph-long note to the set of oil copies after the *Caprichos,* which, being of a dubious nature, had been withdrawn from public sale in Paris in 1856.[8] They seem not to have been withdrawn from circulation entirely. For at some later date, possibly in 1882,[9] one

came into the possession of Museum trustee Samuel P. Avery, who presented it to the Metropolitan in 1894 as an "Original Study for the Etching No. 60 in 'Caprichos' 1799" (fig. 22). No doubt Avery, given his intimate knowledge of prints (he had been a commercial engraver before embarking on a successful career as an art dealer and adviser), identified the image. By 1940 it was recognized as one of the infamous copies after, as opposed to an "original sketch for" plate 60, *Ensayos* (Trials) in *Caprichos*.[10] Ironically, the shadowy origin of the painting seems prophetic of its disappearance a century later. Records indicate that the "Caprichos" oil was stolen from the Museum's "boiler room" in the mid-1950s. In the end, the work of a forger became the object of theft. By that date, it had languished in storage for thirty years. Yet through the early 1920s, both the "Caprichos" oil and the "Jewess of Tangiers" were continuously exhibited and catalogued by the Metropolitan as Goyas.

Real understanding of the Spaniard's oeuvre was slow in coming to America. Goya's earliest biographers recognized that outside Spain the artist was known primarily, if not solely, as the author of *Caprichos*; they tried to remedy this imbalance by devoting more attention to his paintings, in text and reproduction, and also endeavored to dispel common misconceptions about his brash and reckless technique.[11] Nonetheless certain myths died hard. In the Metropolitan's 1905 catalogue of paintings, one reads that Goya "painted with dashing boldness, sometimes executing an entire piece with his palette knife and put in the delicate touches of sentiment with his thumb."[12] As a corrective to this view, author Charles Yriarte had advised his readers in 1867 that Goya could "turn out to be as refined and polished as the great French masters of the last century."[13] Proof of this came to the Metropolitan in 1906.

This was the year that the Museum, thanks to purchase funds provided by Jacob S. Rogers and the brief but illustrious tenure of Roger Fry as curator of paintings, acquired its first bona fide Goya: the artist's 1792 portrait of his friend the successful merchant and distinguished collector from Cádiz Don Sebastián Martínez y Pérez (fig. 23). On a buying trip abroad, Fry discovered the "very remarkable" portrait at a dealer's in London and recommended its purchase in a letter to Director Sir Caspar Purdon Clarke on January 7, 1906: "As the Museum contains no example of Goya's portraiture and as this is a particularly fine sober and accomplished example, I think it should be considered."[14] Three months later the "unusually careful and serious" painting by Goya was published in the Metropolitan's *Bulletin* as a "principal accession" and installed in the galleries.[15]

When the portrait was first placed on view in the spring of 1906, Fry ensured that it was shown to its best advantage. He did not hang it with the miserable "Goyas" that were a carryover from our nineteenth-century heritage, but with other works of like quality and aesthetic interest—namely, other recent acquisitions and "a selection of the more important masterpieces which the Museum contains, scattered at present among works of inferior merit, the incongruity of which tends to detract from their effect."[16] A gallery was specially designed for the display, Fry having worked closely with architects and painters to achieve what he called a "wonderful smalto effect."[17] His efforts were not lost on the critics, many of whom specifically named the Goya *Don Sebastián Martínez* in their short-list of important acquisitions.[18]

Whether set against the ultramarine walls of Fry's model gallery or placed elsewhere in the Museum, the Martínez portrait made an impression. For the poet Ezra Pound, who first admired our "Goya in a blue coat" when he saw it in New York in October 1910, it would stand out, even years later, as the "best" example he knew.[19] Taking his reader on a whirlwind tour of the greatest masterpieces in Italy and elsewhere in Europe, pausing only long enough to mention the "Egyptian sculpture in the British Museum,"

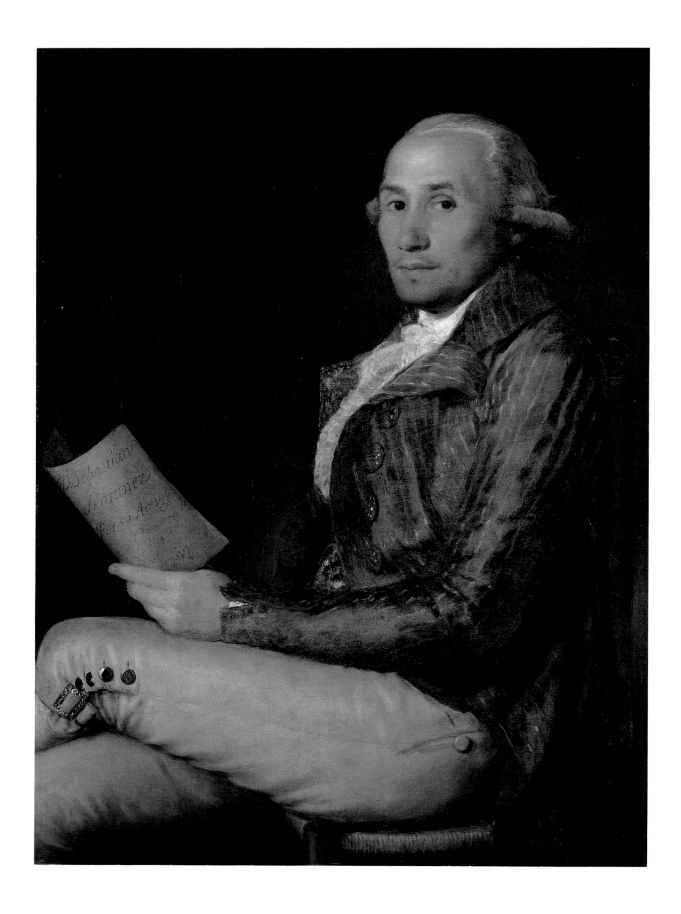

the "pictures in the Louvre," or "the early Italians in London," Pound concluded his 1938 *Guide to Kulchur* with the sentence: "Goya, yes Goya. The best one I know is in New York."[20]

The distinctive qualities of the Martínez portrait gave it broad appeal that extended from aficionados of Goya's art to those, like Fry, who were not.[21] American artist Kenyon Cox otherwise disparaged the "romantic and eccentric painter whom it has become the fashion among extreme modernists to admire somewhat extravagantly." Yet Cox could not help but admire "the quiet solidity, the evenness and smoothness of this painting. The head is soundly and quietly executed but the most remarkable thing in the picture is the painting of the steel-blue coat. . . . Go up close and look at that coat and you will find that over a warm ground it has been painted with almost infinitesimal draggings of fluid semi-opaque color, so thin as to be almost transparent. These little cool blue upper paintings are laid on with the utmost delicacy and the whole coat is one shimmer of light."[22]

In his two-year tenure as curator, Fry succeeded in making the "galleries . . . richer by such masterpieces as the portrait of Martinez."[23] But he left to Bryson Burroughs, who assumed the post in 1907, another principal objective: the "arrangement of the galleries of paintings by schools," which was progressing "as rapidly as conditions permit." This was slowly. It was not until 1910 that the Museum had a sufficient number of paintings for a Spanish school gallery. And then, "the opening of this gallery was [only] made possible at this time by the reception of some important loans."[24]

It is fitting that the majority of loans came from

Archer M. Huntington, the devotee of Spanish art and culture who founded New York's Hispanic Society. They included a Zurbarán, an El Greco, and a "fine Portrait of Don Pedro Mocarte by Goya."[25] Of the paintings by Goya in Huntington's collection—all regrets aside for the fact that the great *Duchess of Alba* was not lent before testamentary restrictions precluded its leaving the Hispanic Society—the intimate, half-length portrait of choir singer Pedro Mocarte made most sense in our galleries, both in 1910 and when it was lent to the Metropolitan two years earlier. "Much freer in handling and more intense in characterization than the Museum's own example," it allowed instructive comparison with our *Don Sebastián Martínez,* "which, however, is more precise in drawing and more contained in brush work than was [Goya's] usual custom."[26] The public would not again have the benefit of a comparable pendant until 1915, when the bequest of Theodore M. Davis enriched our holdings with the portrait *Don Tiburcio Pérez y Cuervo, the Architect* (fig. 18). The Davis bequest also provided a sense, albeit an imperfect one, of Goya's approach to royal subjects in *Infanta María Luisa and Her Son Don Carlos Luis* (fig. 24), which is no longer attributed to Goya, but seems to be based on an oil sketch he "made in preparation for her likeness in the great group of the family of Charles IV, that monstrous lampoon in the Prado" (fig. 10).[27] These works were not formally accessioned until 1930 but remained on loan in the interim period.

Over the next years other loans enhanced the galleries. In 1911 and again in 1918 the *Bullfight in a Divided Ring,* which in 1922 would become our second and only other painting by Goya acquired by purchase (but is now considered the work of an imitator), was lent by an anonymous New York collector. In 1920, at the time of the "Fiftieth Anniversary Exhibition," "three characteristic portraits by Goya, the pair of likenesses representing Don Ignacio Garcini

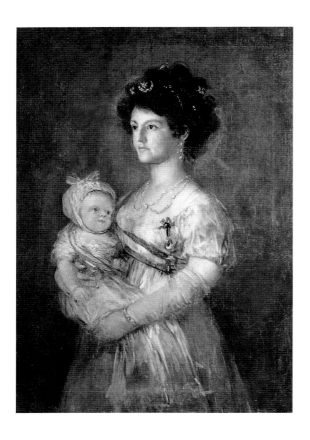

and Dona Josefa Castilla-Portugal di Garcini, and the
portrait of young Victor Guye, the latter lent by J.
Horace Harding,"[28] lived among other Goyas, El
Grecos, and Velázquezes—real and alleged, owned and
lent—in the eclectic context of our Spanish school
gallery (fig. 25). The Garcini portraits remained on
loan from Harry Payne Bingham until 1927; in
1955 they were bequeathed by him to the Museum
(figs. 11, 12).[29]

Given the number of portraits in our galleries,
which rose from one to five between 1915 and 1920,
the Metropolitan was better equipped to challenge
critics, who in 1915, had accused the institution of
having "strangely neglected" the artist because his
works were so "indifferently featured" here.[30] Though
the paintings galleries offered the most conspicuous
evidence that the Metropolitan had turned a corner
in its appreciation of Goya's art, the real turning point
had taken place behind the scenes.

The single most significant event in the develop-
ment of the Museum's collection of works by
Francisco de Goya happened in December 1916. This
was when the Metropolitan, having received from the
estate of publisher Harris Brisbane Dick a collection

of prints and acquisition funds of about a million dol-
lars, established its Department of Prints and hired
New York lawyer William M. Ivins, Jr., as its founding
curator. The Museum now had the means to acquire
prints by Goya; though Ivins would be the greatest
asset, gifts of prints were the immediate result. Among
the very first received, in December 1916, were five
etchings from the first edition of Goya's *Tauromaquia*
(16.4.1–5) and six etchings from the *Caprichos*
(16.4.6–11). In 1918 M. Knoedler and Co. presented
the Museum with a bound first edition of the eighty
Caprichos (18.64[1–80]), and in 1922 a *Disparates* proof
came from Miss Anna Pellew (22.4). Yet even by this
date, gifts (and these are the only ones received until
1936) represented but a small fraction of the Goya
print collection, which Ivins, in his essay for the
Museum *Bulletin,* "Five Years in the Department of
Prints," placed at "fifty-seven Goyas" plus the set of
the eighty *Caprichos.*[31] Purchases account for the bal-
ance, which, two decades after Ivins's arrival at the
Museum, numbered nearly three hundred prints.

By 1936 the Metropolitan's extensive and rich col-
lection of Goya's prints was almost as complete as it is
today. This was a remarkable achievement by any

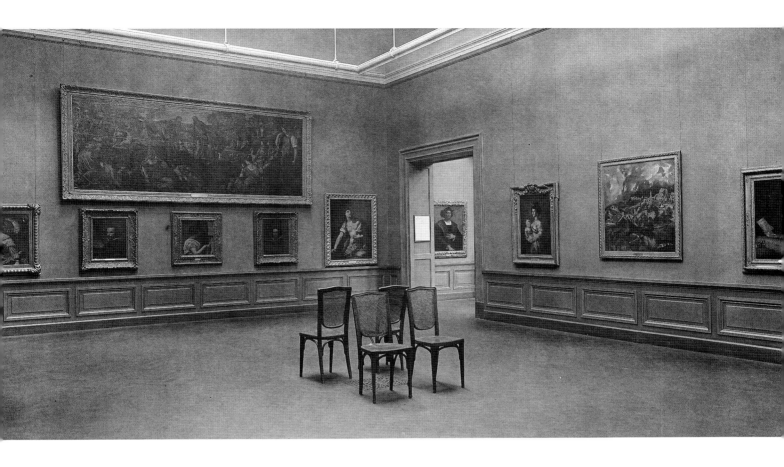

FIGURE 25

View of the Spanish school gallery (Gallery C28) in 1920. The left wall is dominated by Tintoretto's *Miracle of the Loaves and Fishes* (13.75); below it are portraits predominately from the workshop or the school of Velázquez. On the right wall, El Greco's *View of Toledo* (29.100.6; then on loan from the Havemeyer collection) is flanked by *Infanta María Luisa and Her Son Don Carlos Luis,* a copy after Goya (30.95.243), and *Don Sebastián Martínez y Pérez,* by Goya (06.289)

standard, but particularly at a time, as one senses from the tenor of Ivins's writings, when Goya's graphic art was not yet favored, even disliked with "vehemence" by a good segment of the New York public. Hence, in 1918 when the Museum acquired the set of *Caprichos,* Ivins recognized that it was "difficult to appreciate these very wonderful prints justly," since opinion was sharply divided as to their artistic value and the taste of American collectors lagged behind that of their European counterparts, "who believe that taken together they constitute Goya's masterpiece, and that Goya is the greatest etcher since Rembrandt."[32] This changed. Ten years later, Ivins credited "time with its softening hand [as having] at last made this great artist palatable to those of tender stomachs and academic minds,"[33] but the fact is he played an instrumental role—not least for speeding up the process.

It was, of course, Ivins's passion for prints that ultimately determined his vocation. Yet to some degree his success as a curator—that he managed to acquire and regularly exhibit[34] so enormous a collection of controversial objects and eventually make them "palatable" to a wider audience—may be attributed to his legal training, especially his skill as a litigator. Ivins did not simply write about Goya prints, he advocated their appreciation. He wrote about Goya the way he might have composed a legal brief. On each occasion that he turned to the subject—and this was frequently since each major new acquisition demanded a note for the "recent accessions" page of the *Bulletin*—Ivins marshaled his considerable knowledge and understanding about the historical and artistic reception of these images into a brilliant, cogently stated, and always compelling "defense" of their

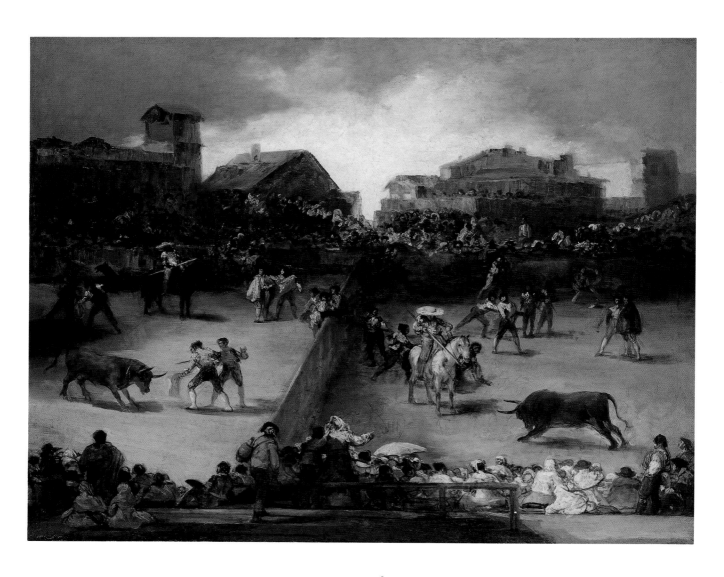

FIGURE 26

Style of Goya, Spanish, early 19th century, *Bullfight in a Divided Ring.* Oil on canvas, 38¾ x 49¾ in. (98.4 x 126.4 cm).
CATHARINE LORILLARD WOLFE COLLECTION, WOLFE FUND, 1922 (22.181)

42

importance. Though the content of each essay was different, their substance (or his "summation") was always the same. So was his approach. He invariably acknowledged, as he did of the *Disasters of War,* that Goya's graphic art was "only for the stout-hearted." Yet regardless of the vagaries of taste, it was indisputably the "most important contribution to the artistic history of etching since the time of Rembrandt."[35] One can compare, for example, Ivins's discussion of the *Caprichos* in 1918: "They are not pretty and they are not charming, but they are very great and very powerful pictures," to the somewhat more bold pronouncement of 1920: "Whatever one may think of his frequently gruesome subject matter there is no denying his tremendous power and strength and his mastery of design and draughtsmanship."[36] The analogy to Rembrandt was a frequent leitmotiv.

Above all, Ivins brought to his curatorship a passion for Goya prints that had been fueled early on by the "wild excitement" he had "never forgotten of the day when as a lad of twenty" he chanced upon an album of Goya's *Disasters of War* in a bookseller's stall along the quay in Paris which he purchased for sixty francs. Indeed, so powerful was "the memory of that first great visual emotion"—these images were "like some powerful dye [that] had worked their way into the woof of his thought and colored it indelibly"—that it took Ivins "three years . . . to get a start for an article about the Disasters of War." The series that Ivins acquired for the Museum in 1922 was no longer a "recent accession" when his article appeared in the "staid and too often professionally bored pages" of the Museum's *Bulletin,* but it is undoubtedly the most moving and candid tribute ever written—there or elsewhere. By 1924 Ivins had so thoroughly chronicled the historic, social, and artistic context of Goya's prints against the "chorus of execration, toleration, and praise," that perhaps all he had left to say was "what one really thinks."[37] (He had, of course, done this all along.)

Ivins's enthusiasm seems to have been contagious. Surely it is no coincidence that in 1919, a year after the *Caprichos* entered the collection, Bryson Burroughs bought the Museum's first drawing by Goya, a brush, ink, and wash sketch titled *Pesadilla* (Nightmare; fig. 9). Though he was uncertain of its place in Goya's oeuvre, whether it was perhaps "an unused project for one of the Caprichos or else one of the similar drawings . . . made later in life," and had "no clue to its exact meaning," he found it "a whimsical composition" and representative of Goya's drawings, which "like the etchings of the Caprichos series, are all political and social satires."[38] Then, in 1922, Burroughs purchased a painting he had known for some time: *Bullfight in a Divided Ring* (fig. 26). Again, the date of acquisition is telling, since a year earlier Ivins had mounted a small exhibition devoted to the subject: "Bullfight Prints by Goya." Held in the Print Room, from March 12 to April 12, 1921, it featured a selection of prints recently acquired: the four lithographs that comprise Goya's *Bulls of Bordeaux* (20.60.1–4; see fig. 20) and the suite of etchings from Goya's *Tauromaquia* (21.19.1–33; see fig. 19).

Insofar as the print collection seems to have provided the necessary impetus for these acquisitions, both were very much in keeping with Burroughs's taste. For him, what was "particularly striking" about Goya's art was his "realism . . . in contrast to the polite and affected styles of the eighteenth century out of which he suddenly emerges." Burroughs found this aspect of Goya's art in the prints, which "placed [Goya] among the great realists of the whole history of art," and in the *Bullfight*—"no better example than our picture could be found to show the revolution of style which Goya effected." But of the "five [portraits] . . . in our galleries . . . fine as they are, a full comprehension of the energy of his many-sided genius is not to be obtained from them."[39] Burroughs had revealed this distinction when he recommended the purchase of the painting, arguing: "Its acquisition

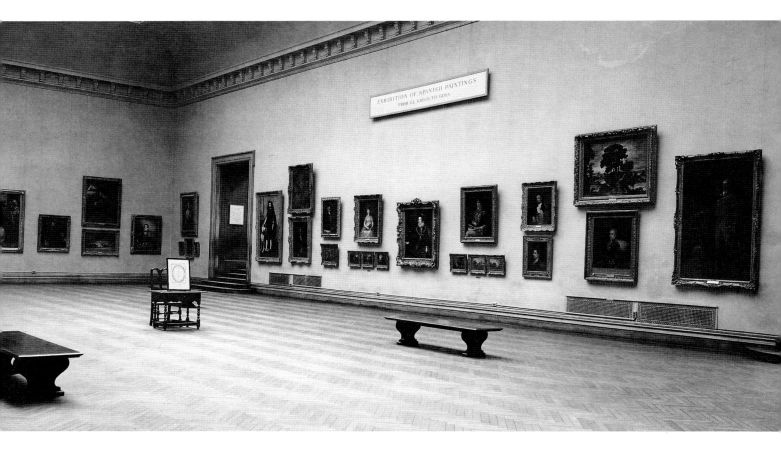

FIGURE 27

Installation view of the exhibition "Spanish Paintings from El Greco to Goya,"
held at the Metropolitan Museum in 1928. Among works on loan are Goya's *Don Manuel Osorio* (end wall) and
Tadeo Bravo de Rivero (far right on the long wall), next to *Don Bernardo de Iriarte,* a copy after Goya

would be valuable both as a representation of the more important side of Goya's work and as an example of a starting point of late nineteenth century painting."[40] And he carried it out when he installed the *Bullfight* in the galleries. In 1924, it was exhibited not with the five portraits in the Spanish school gallery but in a room devoted to modern European painting. In this room, which was dominated by Rosa Bonheur's *The Horse Fair* (87.25) and Emanuel Leutze's *Washington Crossing the Delaware* (97.34) and included paintings by Jozef Israels, Hans Thoma, and Mariano Fortuny, the *Bullfight* hung on a wall next to Wilhelm Leibl's *Peasant Girl with a White Head Cloth* (16.148.1).[41]

Burroughs's desire to feature Goya as "the forerunner of both the romantic and the realistic movement of the last century" would be reflected four years later.[42] It governed his efforts, albeit not fully

realized, to include representative figure paintings in his selection of loans for the Metropolitan's vastly popular exhibition "Spanish Paintings from El Greco to Goya," held from February 17 to April 15, 1928. Unfortunately, as he remarked in the catalogue, "there are several works of the sort owned in America which could not be borrowed"; hence "with the exception of . . . [another] Bull Fight and . . . [a] series of six little panels illustrating the history of the Capture of a Brigand by a Monk, all of Goya's pictures in our exhibition are portraits."[43]

That most of the loans were portraits was determined not by choice but by availability. Burroughs made some attempt, in an article in the *Bulletin,* to explain why this was true of the "large number of Goyas in America." Not only do they "appeal particularly to our tastes" but "by good chance [they] happen to have been procurable, at least up to recently. . . . The fact

that great numbers of his portraits were until late privately owned in Spain, in most cases by the descendants of those whom he painted, made possible their exportation."[44]

The exportation of Goya paintings from Spain by American collectors, which began at the turn of the century and peaked just prior to the outbreak of World War I, seems to have been initiated in 1897 by Louisine and H. O. Havemeyer and brought to a glorious conclusion in such purchases as the three acquired by Henry Clay Frick in 1914. The Havemeyers were among the few Americans who had bought more or less directly from private Spanish collectors, and Mrs. Havemeyer (after the death of her husband in 1907) continued to ferret out paintings from descendants (real or alleged) through well-placed agents in Madrid. She did so even when, owing to tighter restrictions on the exportation of these works, this seemed to present "a risk," and code names had to be used in letters regarding potential acquisitions.[45] Given her contacts in Madrid, Mrs. Havemeyer often served as a "scout" for important works for her friends, among them Frick (though none came to fruition) and Oliver Payne, for whom she arranged the sale, in 1910, of the Garcini portraits from the nephew of the sitters portrayed.[46] (In turn, Payne left them to his nephew, Harry Payne Bingham, who left them to the Metropolitan.) Archer Huntington represented the other extreme. His great devotion to Hispanic art and culture and his friendship with King Alfonso XIII sensitized him to the plight of a country being divested of its treasures, "and, very honorably, he never bought any of his works of art in Spain."[47] Yet even when paintings were bought from galleries (Durand-Ruel and Knoedler being the principal dealers at the time), the transfer was virtually direct. The provenance of the portrait *Don Tiburcio Pérez y Cuervo, the Architect* (fig. 18) is a case in point. The painting was purchased by Durand-Ruel from the sitter's nephew in February 1903 and sold to

Theodore M. Davis that June. Twelve years later it was bequeathed to the Metropolitan Museum along with the *Infanta María Luisa and Her Son* (fig. 24), formerly owned by artist Eugène Fromentin, that Davis had bought in Paris in 1904.

While nearly all the paintings that now comprise our Goya collection were in America by 1915, and many a decade earlier,[48] none came to the Metropolitan so soon after they "had found their way to these fortunate shores"[49] as the two from Theodore Davis's estate. Thus the paintings that have entered our collection over the years are very much a reflection of turn-of-the-century taste and availability. This is true not only of the two from the Davis estate and the five from the Havemeyer bequest of 1929, but also those donated to the Museum after mid-century. *Don Bernardo de Iriarte,* bequeathed by Mary Stillman Harkness in 1950 (and now regarded as a copy after Goya's original in the Musée des Beaux-Arts, Strasbourg; 50.145.19),[50] was purchased by her husband in 1912. *Ferdinand VII, When Prince of Asturias* (now thought to be a copy based on Goya's preparatory sketch for his likeness in the *Family of Carlos IV* [see note 27]; 51.70) was acquired by an American collector in 1910 and was owned by at least two other individuals, here and abroad, before René Fribourg bought it in 1950 and gave it to the Metropolitan a year later. Then there are the Garcini portraits, bequeathed in 1955 (figs. 11, 12); the portrait *José Costa y Bonells, called Pepito* (fig. 37), which had belonged to various Americans since 1906 and was presented by Countess Bismarck in 1961; and *The Countess of Altamira and Her Daughter* (fig. 5), which was acquired by Philip Lehman about 1911 and entered the Museum in 1975 as part of the collection of his son, Robert Lehman. There is only one exception: *Don Manuel Osorio Manrique de Zuñiga* (fig. 1), which Jules Bache acquired in 1925 from the French playwright Henri Bernstein, lent to the Metropolitan's "Spanish Paintings" exhibition in 1928, and bequeathed to the Museum in 1949.

The very fact that "there are many portraits by Goya in this country and [the Metropolitan] can expect that several of them will find their way to our collection" was a sound argument for Burroughs's acquisition of the *Bullfight,* since "pictures of this sort are rare in America."[51] His purchase of the work at the end of 1922 and the publication of his "recent accession" essay in the *Bulletin* in 1923 brought him in touch with Goya scholarship. The result of his researches were reflected not only in the pages of the *Bulletin,* where he identified the comparative images that are now thought to be the source for this pastiche,[52] but in the Spanish school gallery as well. It was precisely at this time that Burroughs finally took down the two "Goyas" (figs. 21, 22) which had been carryovers from the Museum's nineteenth-century tradition.

Outside the Museum, neither of these two works had been seriously entertained as a genuine or even "doubtful" Goya. They were not included in any of the critical catalogues published prior to August L. Mayer's authoritative study of 1924. Nor were they among the 732 Goya paintings listed in Mayer's catalogue raisonné, since he had long held that they were "not by Goya" and had advised the Museum of his opinion in 1914.[53] In any event, after the publication of Mayer's book Burroughs, who had already retired these works to storage, at last dropped the "Jewess of Tangiers" and the "Caprichos"—which he had retitled *The Trial: A Scene of Sorcery*—from his *Catalogue of Paintings.* Though otherwise ignored (they were, for example, never mentioned in the *Bulletin*), both paintings had been continuously listed as by Goya in the first seven editions of his catalogue from 1914 to 1924. (*The Trial*—outlasting the "Jewess of Tangiers" by one edition—still appeared in the 1926 catalogue as well!) However, in the ninth and last edition of 1931, the pages that had for many years recorded our first "Goyas" were now given over to our newest acquisitions: the five paintings bequeathed to the Museum by Mrs. H. O. Havemeyer in 1929.

Louisine and H. O. Havemeyer were pioneers in the collecting of Spanish pictures. In its day their collection, which furnished the contents of an exhibition, "Paintings by El Greco and Goya," at M. Knoedler and Co., New York, in 1912, was large, impressive, and well known. When three years later the same gallery mounted another exhibition of the same title, savvy journalists speculated as to the likely source: "From whence come the . . . Grecos and Goyas assembled at Knoedler's? For reasons best known to themselves, and respected by the Gallery, the names of the owners of the loans are not in the catalog. Mrs. Havemeyer, I am told, however, called off her customary Sunday afternoon musicale, so that the void on the walls might escape comment."[54]

Today the Havemeyers' collection of Goya paintings is less highly esteemed (only three of the seventeen they owned, and none of the five given to the Metropolitan, are widely regarded as authentic). However, this does not diminish the role the couple played in establishing a market for such works in America. Ironically, it was this very market—the rapid increase in prices, and the demand filled with a supply of look-alike or not-so-like Goyas—that undermined the collection. The overall weakness of their holdings is especially curious since the Havemeyers knew firsthand "nearly all the great Goyas in Madrid"[55] and were aware of the frequent practice of owners having copies "made to fill the empty space" as well as the risk of "art collectors [being] deceived by them."[56] Yet they "were never able to buy [certain paintings] during Mr. Havemeyer's lifetime, and after his death, when they were offered to [Louisine Havemeyer], Spaniards' heads had been turned and the prices were prohibitive."[57] Mrs. Havemeyer never quite adjusted herself to the new prices (as was also true with works by Courbet) and either passed over, or passed along to her friends, a number of great Goyas for lesser examples, both in price and in quality.[58] Insofar as other factors—among them state of knowledge, poor advice, and the desire to have a representative Goya collection—contributed to a less than satisfactory group of works, taste seems to have played a decisive role.[59]

FIGURE 28

Style of Goya, Spanish, 19th century, *A City on a Rock*. Oil on canvas, 33 x 41 in. (83.8 x 104.1 cm).
H. O. HAVEMEYER COLLECTION, BEQUEST OF MRS. H. O. HAVEMEYER, 1929 (29.100.12)

Mrs. Havemeyer's preference for "pretty" Goyas (not a distinctive characteristic of his works) made for some bad choices. Of the two portraits of the duchess of Alba "offered to us," Mrs. Havemeyer wrote in her memoirs, they "passed" on the celebrated painting that is in the Hispanic Society—"she is not so attractive in this portrait, nor very young either"—for another likeness, now thought to represent neither the duchess nor Goya—where "she is still beautiful and still young."[60] Nor did she pursue the great *Marquesa de la Solana,* albeit "one of Goya's best portraits, but unfortunately not the portrait of a beautiful woman."[61] Such pictures as the little *Condesa de Haro,* a "pretty creature . . . so entrancing in her youth and grace," appealed to her sensibilities.[62] Of course, the

sweet prettiness of the faces of the *Majas on a Balcony* (fig. 43) from the Havemeyer collection (recently doubted) is among the features that distinguishes it from the undisputed version of this painting, which is privately owned (fig. 42).[63]

The *Majas* was among "the Goyas, of which there are five" that were included in Mrs. Havemeyer's bequest to the Metropolitan of 1929. When the group was described in the Museum's *Bulletin,* comments were confined to this "delightful" painting, in which Goya "is at his most Venetian, reveling in the gay picturesqueness of life . . . and . . . in the brilliant lightness of his own magical touch," and to the "fantastic City on a Rock" (a Goyaesque pastiche; fig. 28), which "will challenge attention by reason of its fresh vitality

FIGURE 29

Attributed to Goya, *Doña Narcisa
Barañana de Goicoechea*. Oil on canvas,
44¼ x 30¾ in. (112.4 x 78.1 cm).
H. O. HAVEMEYER COLLECTION, BEQUEST
OF MRS. H. O. HAVEMEYER, 1929
(29.100.180)

and modernity."[64] Yet there were three portraits as well. One Mrs. Havemeyer described as "the famous portrait of the Countess of Giocoechea [*sic*]—a portrait that a popular critic said he thought 'as fine as a Velazquez'" (but which now appears too formulaic in conception not to suspect the hand of a clever imitator; fig. 29).[65] Another was the "portrait of the Queen," which they "really bought . . . because the costume was so wonderfully painted" (it was recognized as a paltry copy by 1940; see note 27 and fig. 30).[66] And the third, the *Portrait of a Man* (fig. 31) formerly thought to represent the likeness of painter Vincente López, was even doubted at the time of sale, carried a spurious signature, and was determined to be a "fraudulent imitation of Goya" in 1935. (Recently,

however, it has been attributed to the Neapolitan painter Gaspare Traversi, an assignment that accords not only with its style but its provenance; it was purchased in Italy in 1912).[67]

In 1930 the bequest of Theodore M. Davis was finally settled after years of prolonged litigation, and the two Goya portraits that had been on loan from his estate since 1915 were formally accessioned. In 1931 the Museum received from the estate of Michael Friedsam a large and varied collection that included another Goya portrait, the handsome full-length likeness of Tadeo Bravo de Rivero (fig. 32). The portrait did not remain part of the collection for very long. Three years later it and some twenty other pictures became the property of the Brooklyn Museum.

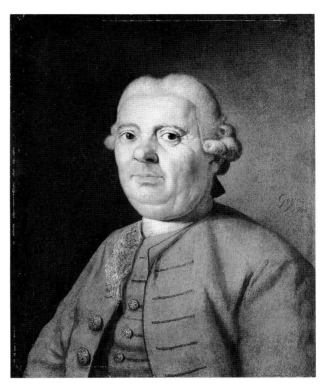

FIGURE 30

Copy after Goya, Spanish, after 1800, *María Luisa of Parma, Queen of Spain*. Oil on canvas, 43½ x 33½ in. (110.5 x 85.1 cm).
H. O. HAVEMEYER COLLECTION, BEQUEST OF
MRS. H. O. HAVEMEYER, 1929 (29.100.11)

FIGURE 31

Attributed to Gaspare Traversi (Neapolitan, ca. 1722–1770), *Portrait of a Man*. Oil on canvas, 22 x 17½ in. (55.9 x 44.5 cm). Inscribed (right center): Goya / 1780.
H. O. HAVEMEYER COLLECTION, BEQUEST OF
MRS. H. O. HAVEMEYER, 1929 (29.100.179)

The terms of Friedsam's will had stated that his collection should, "so far as practicable, be kept together and separate and apart by itself," at the Metropolitan, or at some "other institution in the City of New York competent . . . to receive and hold the same, in such manner and upon such terms as my said trustees shall deem best."[68] The requisites of space and the nature of the collection, however, made it not "practicable" to keep the estate intact and permanently segregated at this institution (or elsewhere in New York). "In accepting the collection, the trustees referred to Friedsam's 'well-known and practically expressed interest in education,' which somehow made it possible for 'the influence of the collection . . . [to] be promoted in the widest degree without hampering conditions usually associated with restricted gifts.'"[69] Hence Friedsam's great Italian and Flemish pictures, his sculptures, porcelains, and other works of art were disbursed throughout the Museum where they would have the greatest "influence." Nearly two dozen paintings that were "no longer desired by the Museum" and would have been kept just for loan purposes were transferred to Brooklyn.

There is no firm documentation in our Archives concerning what prompted the Board of Trustees, in May 1933, to "consider the return of such paintings as may not now be desired by this Museum, for transfer by the executors to the Brooklyn Museum."[70] But after the paintings were moved to Brooklyn in February 1934, Herbert Winlock, director of the Metropolitan, described the action as a "proper solution to the matter" and a "completely logical arrangement." Whereas these paintings would have been kept by the Metropolitan for "loan purposes only," their placement in the Brooklyn Museum assured the "practically permanent use of the pictures and in Colonel Friedsam's own city."[71]

The fate of Goya's *Tadeo Bravo* had actually been decided in May 1933 when Bryson Burroughs listed the painting among those not really "desired" by the Museum, and a special committee of trustees confirmed his opinion.[72] How did the Metropolitan make what now seems such a mistake? Perhaps the lifesize painting simply arrived at the wrong time in history. We had just received a half-dozen Goya portraits; one more, particularly one of the scale of *Majas on a Balcony,* no doubt seemed an unnecessary or undesirable use of gallery space which was already "seriously taxed." In fact, "the crowding of the paintings of the Spanish school" was such that it shortly "necessitated rearrangements which . . . affected four

of the northwest galleries." By 1935 our collection of Spanish paintings—which included not only the Goyas but the El Grecos from the Havemeyer bequest plus the "summer's addition of the Holy Family by Ribera [34.73]"—had outgrown its quarters, the same gallery it had barely filled in 1910, and a "larger and more suitable room" was set aside (fig. 33).[73]

In retrospect it is unfortunate that space was not reserved for the *Tadeo Bravo,* a painting of unchallenged authenticity and great quality. Of the portraits received from the Davis and Havemeyer estates, only one still retains that distinction, the richly painted and penetrating *Tiburcio Pérez* (fig. 18). And it, too, almost fell prey to the same fate as *Tadeo Bravo,* for at one

View of the Spanish school gallery (Gallery C29) in 1935. Along the left wall are paintings by (and after) Goya. At right, El Greco's *View of Toledo* (29.100.6), *Portrait of a Man* (24.197.1), and *Cardinal Don Fernando Niño de Guevara* (29.100.5)

point in its history it also appeared on a "B" list drawn up by Bryson Burroughs. This was in 1925, ten years after the Davis estate was bequeathed to the Museum, and five years before the Museum reached a settlement agreement that enabled us to accession the pictures. Since part of the settlement involved payment by the Museum of a sum of money, some thought was given to selling works for this purpose. *Tiburcio Pérez*—perhaps because it was the more valuable of the two paintings in price (by $15,000) or because Burroughs found "Goya's fiery genius evident in every stroke" of the portrait of *María Luisa* (fig. 24; a particularly telling characterization against the "more solid and deliberate workmanship" of the other) or both—the architect's

portrait was among the paintings that were considered for disposal.[74] When new lists were drawn up, reviewed, and reconfigured in 1930, an important directive was issued by the Museum's president, Robert de Forest: he wanted it "distinctly understood that he desired the selection of objects to be sold out of this collection to be based upon the same principles as all other sales of Museum objects, that is, that he wished the selection to be confined to objects which the Museum would not care to keep, and he would disapprove entirely of the selection being based on the Museum's need of money to make up payments called for by its acceptance of the bequest."[75] In the final distribution, both Goyas ended up on Burroughs's

now-much-longer "A" list, and they remained there, pursuant to review by the Executive Committee on Paintings chaired by Horace Havemeyer. Among paintings that never made it to the "A" list, however, but which in the end were not sold, were two of the three Monets from Davis's estate.[76]

In 1935 the intervention of another Museum president, George Blumenthal (1933–41), would have a staggering impact on our collection of works by Francisco de Goya. Fifty drawings, which had been culled from four of the artist's sketchbooks (Albums B, D, E, F) and assembled in a scrapbook, suddenly appeared in Paris. Having belonged since the nineteenth century to Federico Madrazo and in turn to his grandson Mariano Fortuny y Madrazo, they "were virtually unknown to scholars until they were exhibited [in the summer of 1935] at the Bibliothèque Nationale." Not only were they of exceptional quality and considerable range, but the "opportunity to acquire such a group [was] surprising, as even single drawings by Goya seldom come on the market. The great collections of drawings in the British Museum and Kupferstich Kabinett (Berlin) contain very few and the Louvre none at all. The majority are owned by the Prado."[77] This was the case when Harry B. Wehle, who became curator of paintings after Burroughs's death in 1934, submitted a recommendation for the purchase of the drawings to the director and the Committee on Purchases in August 1935. That the "Louvre [had] none at all" was something of a triumph for Wehle since he had spent the previous few months tracking the various offers made by and rejected from the Louvre—our fiercest competitor. The Louvre's offers remained low, and the price stayed high, and among other solutions that Wehle had entertained were splitting the group with the Louvre or selling part to Paris dealers. In early July, "before the possibility of losing the drawings," the Louvre made a stopgap offer on the "basis of *immediate payment*." A reply, advised our agent in Paris, was needed "*at once.*"

A telegram sent by Wehle to Director Winlock on July 11 announced the outcome: "Album of fifty Goya drawings . . . Rescued . . . Blumenthal personal purchase . . . fourteen racy early drawings. Remainder considered late. Include ten to twenty superb dramas." Blumenthal sold the drawings to the Museum for what he had paid, and they were accessioned in October 1935.[78]

Wehle deserves credit for ushering through the purchase and for having coined the phrase "black border series" for Goya's drawings from Album E when he published the acquisition in 1938.[79] However, William Ivins, curator of prints, seems to have been a silent partner in bringing it about. He not only endorsed but initiated the purchase, both directly and indirectly.[80] The Metropolitan did not have a department of drawings until 1960, but a niche had already been carved to receive just such a group. The lack of drawings by Goya had been sorely felt since October 1928, when Ivins mounted from our holdings a small Goya exhibition in the print room and installed "a number of facsimiles of [some of the] more important examples."[81] In this respect the "niche" made for the drawings took a quite literal form.

In 1936, "in celebration of the acquisition of [this] album of fifty drawings . . . the Museum [held] an exhibition of Goya's works in various media. . . . Except for a few paintings borrowed for the occasion, all the works shown [were] taken from the Museum's own galleries and portfolios. These include[d] eight paintings by the master, one drawing in addition to the fifty just purchased, and an exceptionally rich and complete collection of prints."[82]

It would be some forty years until a handful of new drawings entered the collection. Two, which were included in the Museum's 1955 exhibition "Goya: Drawings and Prints," were bequeathed by Walter C. Baker in 1971: *Hanged Man* (1972.118.9; since deattributed as a feeble imitation) and a red-chalk *Self-Portrait* (fig. 44), which joined the ink self-

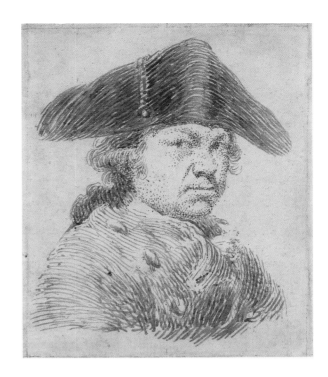

portrait, Goya's celebrated Beethoven-like image of himself, that had served as the frontispiece to the scrapbook of drawings. Soon the Museum could boast three such likenesses: in 1975, *Self-Portrait in a Cocked Hat* (fig. 34) came with the Robert Lehman Collection along with another drawing, *Unholy Union* (1975.1.975). From the bequest of Harry G. Sperling the Museum received a wash and chalk sketch, entitled *Prisoners* (1975.131.219), which was once contested but is now attributed to Goya owing to its recognized provenance and to the discovery of a red-chalk sketch on the reverse. In all, then, only three or four Goya drawings have been added to our holdings since the 1936 exhibition.

Nor has the print collection expanded substantially since 1936. Earlier in the decade, Ivins's long-standing efforts to amass a comprehensive body of Goya's graphic art reached their apogee. In the early 1930s, he greatly augmented our holdings with nine of the artist's early etchings after Velázquez, four early proofs of plates in the *Caprichos,* and twenty-two working proofs of the *Disasters of War,* a group later enriched by exchange (53.540, 53.541) and purchase (1987.1014) of three other examples. Then, in 1935, Ivins acquired what may be seen as the perfect coda to his assemblage: Goya's *Giant* (fig. 15), the rarest and perhaps most powerful print in our collection. One of only six impressions known to exist, this aquatint worked in

the mezzotint manner, depicts a massive figure looming against the heavens. "By leaving the title space blank, Goya freed his Giant to capture our later imagination. . . ."[83]

These words were not written by Ivins, but by his colleague since 1932 and successor from 1946, A. Hyatt Mayor. How apt. The *Giant,* a powerful figure pitted against the horizon, his head glancing backward, anticipated the future and acknowledged the past: it was the first Goya published in the Museum's *Bulletin* by Mayor, and the last acquired by Ivins. With the *Giant,* the formative phase of the print collection ended. For after this date, save the exceptional rare print such as the one purchased in 1987 or the recent promised gift (fig. 3), acquisitions have been limited to late impressions of the *Caprichos* and *Disasters of War.* Their value has been largely educational.

It was not in terms of our holdings, but in our understanding of them, that Mayor made significant contributions in his role as curator. His brilliant interpretative studies of Goya's art and his passion for Spanish culture would, like the dual posts he filled—as curator of prints until 1962 and as president of the Hispanic Society from 1955 to 1980—perpetuate two legacies: that of his mentor, Ivins, and that of his uncle by marriage, Archer M. Huntington.

Unlike the collections of prints and drawings, the real strength of the paintings collection came after

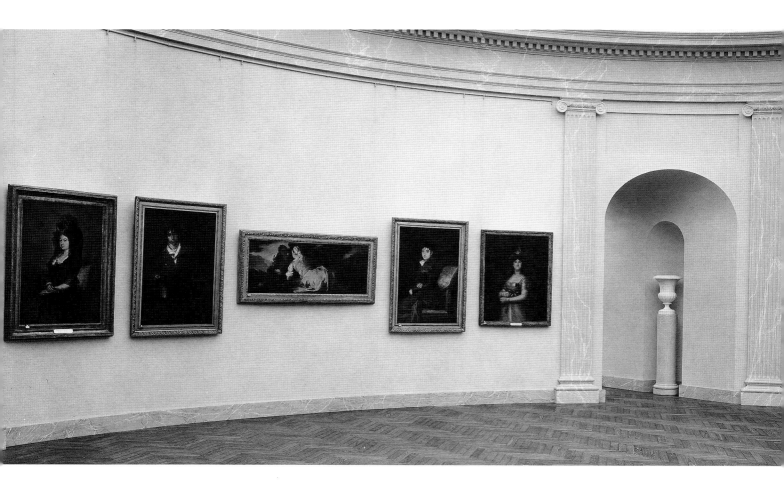

1936. Only recently, however, has this been recognized. Sixty years ago, additions such as the *Tadeo Bravo* (fig. 32) seemed unnecessary, and judging from the only purchase subsequently made—that of an ill-fated portrait miniature secured by Wehle in 1937 (and deaccessioned in 1981)—gaps in the holdings were perceived as small. In the early 1970s the scholarly terrain shifted with the catalogues raisonnés published by José Gudiol and by Pierre Gassier and Juliet Wilson (both in 1971); from this date on, the integrity of the Museum's most prized Goyas began to be challenged, starting with *A City on a Rock* (fig. 28), which artist Roy Lichtenstein has "always loved, although experts no longer think it's by Goya,"[84] and culminating, more recently, with the doubts cast on the authenticity of *Bullfight in a Divided Ring* (fig. 26) and *Majas on a Balcony* (fig. 43). These losses are perhaps most acute; portraits subsequently demoted were compensated for by those gained by gift and bequest.

In 1936, the Museum counted among its holdings "eight paintings by the master." This number did not include either of the two "Goyas" acquired in the nineteenth century, nor all the paintings that had entered the collection as Goyas as recently as 1929. Already one of the portraits from the Havemeyer collection had been rejected (fig. 31), and four years later, when Wehle published his *Catalogue of Italian, Spanish and Byzantine Paintings,* another would follow (fig. 30).[85] Today, only two of the eight paintings are still thought to be "by the master"; the rest have been downgraded or deattributed. The ratio is inverse for later acquisitions; of the seven paintings acquired since 1936, only two are no longer considered to be by Goya.

Sixty years ago, the collection was anchored at one end of Goya's career by the 1792 portrait *Don Sebastián Martínez* (fig. 23) and at the other by the 1820 portrait *Don Tiburcio Pérez* (fig. 18). Lacking the Altamira family portraits of the 1780s and mid-career examples with firm claims to Goya's hand, the paintings collection fell quite short of being representative, even within the narrow scope of documenting his work as a por-

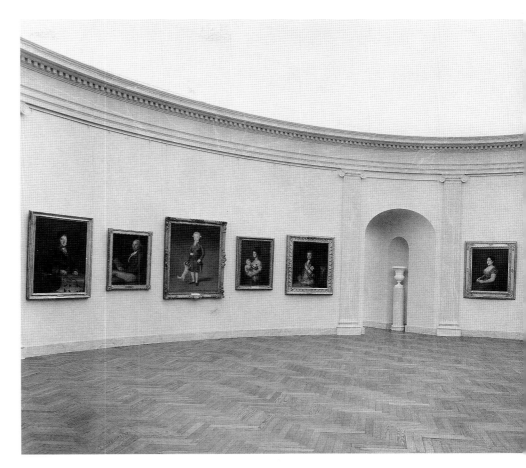

FIGURES 35 and 36

Installation views of the exhibition "Francisco Goya: His Paintings, Drawings and Prints," held at the Metropolitan Museum in 1936. Works on loan include, in figure 35, *Gossiping Women* (Wadsworth Atheneum, Hartford) at the center, flanked by the portraits of Bartolomé and Thérèse Sureda (now, National Gallery of Art, Washington); in figure 36, to the left of the arch, *Don Vicente Osorio* (private collection) is hung in the center of the group of portraits

traitist. At the time of the 1936 exhibition, our holdings were supplemented with loans.

None of the ten paintings borrowed for that exhibition nor the handsome oval room in which they were installed (figs. 35, 36) are part of the permanent galleries today. Yet many of the loans were suggestive of things to come. The Metropolitan did not receive the "piquant portraits of Don Bartolomé Sureda and his wife,"[86] which had initiated the Havemeyer collection in 1897 and were lent by their daughter in 1936, a decade before they were presented, in her parents' memory, to the National Gallery of Art in Washington. But we did receive another pair of portraits—those of Don Ignacio Garcini and his wife (figs. 11, 12) from the bequest of Harry Payne Bingham in 1955—which, as noted, Mrs. Havemeyer was also responsible for bringing to America. In 1936 Goya's portrait of the "shy boy Don Vicente Osorio lent by Mrs. Charles S. Payson"[87] seems to have held a place for the contemporary portraits of his brother *Don Manuel Osorio,* bequeathed by Jules Bache in 1949

(fig. 1), and that of his mother and infant sister, *The Countess of Altamira and Her Daughter* (fig. 5), received with the Robert Lehman Collection in 1975. Nor was the "little boy in red," as *Don Manuel Osorio* is affectionately known, the only child's portrait to enter the collection, for in 1961 Countess Bismarck presented us with what may be seen as a "fascinating pendant," in *Pepito Costa y Bonnells* (fig. 37). As Everett Fahy has noted, "seen together, they show Goya's development from a poetic eighteenth-century painter to a profoundly moving realist of the early nineteenth."[88]

A keener sense of Goya's development along these lines came not only with the growth of the collection but with the reinstallation of the artist's paintings in our permanent galleries. In 1954, when "conventional grouping by national schools" gave rise to "the new arrangement of the picture galleries . . . according to historical periods," the artist—to quote curator Theodore Rousseau—loomed as a "powerful temperament [who] embraced both the eighteenth and the nineteenth centuries. His early pictures such as the

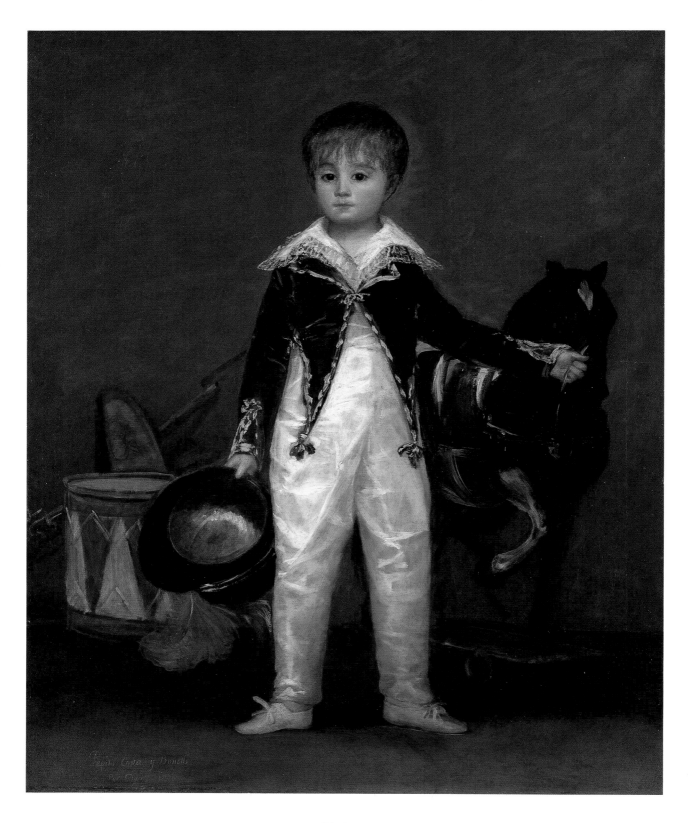

FIGURE 37

José Costa y Bonells, called Pepito. Oil on canvas, 41⅜ x 33¼ in. (105.1 x 84.5 cm).
GIFT OF COUNTESS BISMARCK, 1961 (61.259)

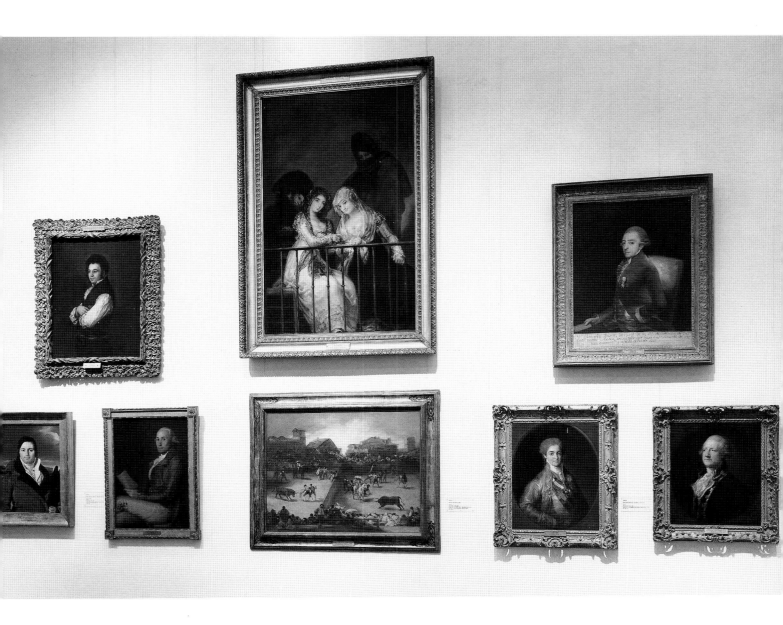

FIGURE 38

Temporary display of European paintings in the north wing of the Museum during the Metropolitan's centennial celebration, 1969. Top, from left to right: Goya, *Don Tiburcio Pérez y Cuervo, the Architect* (30.95.242); attributed to Goya, *Majas on a Balcony* (29.100.10); copy after Goya, *Don Bernardo de Iriarte* (50.145.19). Bottom, from left to right: Ingres, *Joseph-Antoine Moltedo* (29.100.23); Goya, *Don Sebastián Martínez y Pérez* (06.289); style of Goya, *Bullfight in a Divided Ring* (22.181); copy after Goya, *Ferdinand VII, When Prince of Asturias* (51.70); Gainsborough, *Portrait of a Man, called General Thomas Bligh* (60.71.7)

portrait of Don Sebastian Martinez [fig. 23] and the enchanting Don Manuel Osorio [fig. 1] . . . have the clarity and the delicacy of drawing of a Tiepolo or a Nattier, combined with typically Spanish vigor and incisiveness. The mature portraits of Doña Narcisa Barañana de Goicoechea [fig. 29] and Don Bernardo de Iriarte [see fig. 38] are painted with direct and vital realism and the two late pictures, the Majas on a Balcony [fig. 43] and the portrait of Tiburcio Pérez [fig. 18], add to this realism a brooding romantic mood and a breadth of execution which lead us directly into the full nineteenth century."[89]

Goya's paintings would "lead us directly" into the nineteenth century when the Andre Meyer Galleries

opened in 1980. The portrait *Don Tiburcio Pérez,* which had formerly hung next to Tintoretto's *The Miracle of the Loaves and Fishes* in 1918 (fig. 39) and Ribera's *Holy Family* in 1941 (fig. 40), would be seen, in 1969, with Ingres's *Joseph-Antoine Moltedo* (fig. 38) and, some twenty years hence, in the company of a Manet (fig. 41). At the Metropolitan in the decade of the 1980s, Goya emerged not as the last of the great Spanish artists or the youngest of the old masters, but rather as the first of the moderns—just as he had in the Armory Show of 1913, when represented by a miniature,[90] or in 1924 when Bryson Burroughs hung the *Bullfight* in the room of modern European paintings. Within the context of the Andre Meyer Galleries, both Goya and Jacques-Louis David, his exact contemporary, took their respective places at the threshold of a new century: Goya as "the forerunner of both the romantic and the realistic movement,"[91] carried on by Delacroix, Courbet, and Manet, and David as the leader of the neoclassical tradition carried on by Ingres and Prud'hon. Today, both artists, their paintings newly reinstated in the old master galleries, stand at the same threshold, but at the end of one era, as opposed to the beginning of another. The requisites of space, with the eighteenth-century galleries a wing away from those of the nineteenth, are perhaps least kind to these powerful figures whose sixty-year-long careers straddle two ages—the age of artifice and the age of actuality—and whose art recorded the transitions between the two.

FIGURE 39 *(top)*

View of the Spanish school gallery (Gallery C28) in 1918. From left to right: copy after Goya, *Infanta María Luisa and Her Son Don Carlos Luis* (30.95.243); Tintoretto, *The Miracle of the Loaves and Fishes* (13.75); Goya, *Don Tiburcio Pérez y Cuervo, the Architect* (30.95.242); Italian school, *Lucretia* (formerly attributed to Ribera, 12.109; deaccessioned in 1956); El Greco, *The Adoration of the Shepherds* (05.42); Goya, *Don Sebastián Martínez y Pérez* (06.289)

FIGURE 40 *(center)*

View of the Spanish school gallery (Gallery C29) in 1941. On the long wall at left, portraits by (and attributed to) Goya flank paintings by Zurbarán (20.104) and Ribera (34.73). On the end wall are three paintings by El Greco

FIGURE 41 *(bottom)*

View of the Andre Meyer Galleries in 1991. Goya's *Don Tiburcio Pérez* (30.95.242) is hung with Manet's *Young Lady in 1866 (Woman with a Parrot;* 89.21.3) and Turner's *Grand Canal, Venice* (96.29)

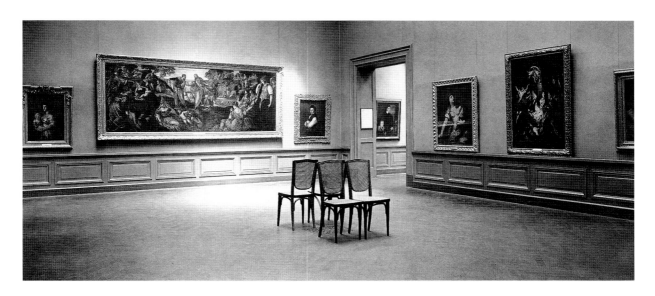

1. H. E. Winlock, "A Goya Exhibition," *MMA Bulletin* 31, no. 1 (January 1936), p. 2; and Preface, *Francisco Goya: His Paintings, Drawings and Prints,* MMA (New York, 1936), p. vii.

2. "An Exhibition of the Work of Goya," *MMA Bulletin* 31, no. 2 (February 1936), p. 22.

3. MMA, *Annual Report of the Trustees of the Association, May, 1872,* pp. 3–4.

4. Henry James, "The Metropolitan Museum's '1871 Purchase,'" in John L. Sweeney, ed., *The Painter's Eye: Notes and Essays on the Pictorial Arts by Henry James* (London, 1956), p. 59; originally published in the *Atlantic Monthly,* June 1872.

5. MMA, *Catalogue of Pictures of Old Masters, Belonging to the Museum* (New York, 1872), p. 41, no. 113.

6. My comments on the extent to which Goya's art was known outside of Spain in the late nineteenth century are based on the researches of Nigel Glendinning, *Goya and His Critics* (New Haven and London, 1977); see in particular, pp. 11–22, and chap. 4, "Romantics and Realists."

7. Gautier, quoted and translated in Glendinning, *Goya and His Critics,* p. 77.

8. Laurent Mathéron, *Goya* (Paris, 1858), n.p., n. 1.

9. In June 1882, Avery bought a "sketch by Goya" from Parisian dealer Arsène Portier for 100 francs; it is the only Goya purchase recorded in his diaries and has not yet been identified. See Madeleine Fidell Beaufort, Herbert L. Kleinfeld, and Jeanne K. Welcher, eds., *The Diaries 1871–1882 of Samuel P. Avery Art Dealer* (New York, 1979), p. 656. In the early 1880s Avery presented Paul Lefort's *Francisco Goya: Etude biographique et critique, suivie de l'essai d'un catalogue raisonné de son oeuvre gravé et lithographié* (Paris, 1877) to the Museum's library.

10. See Harry B. Wehle, *A Catalogue of Italian, Spanish and Byzantine Paintings,* MMA (New York, 1940), p. 254.

11. On this subject, see Glendinning, *Goya and His Critics,* pp. 85–97.

12. *Catalogue of the Paintings in The Metropolitan Museum of Art* (New York, 1905), p. 60. The blurb on Goya in this catalogue conspicuously betrays its reliance on Sir William Stirling-Maxwell's *Annals of the Artists of Spain,* 4 vols. (London, 1848; 2nd ed., 1891), which since mid-century had been the standard reference book for the study of Spanish art. One can compare, for example, the Museum's text, "[Goya's] chief excellence was that of a satirist with a pencil. He may be called the Hogarth in Spain," to Stirling's, "As a satirist with the pencil, Goya stands unrivalled in Spain, of which he may be called the Hogarth." The sentence devoted to Goya's style, quoted above, also comes from Stirling, but the original source for this view was Théophile Gautier. When it came to describing Goya's technique, Stirling deferred to Gautier: "'Smearing his canvas with paint,' says a French writer, 'as a mason plasters a wall, he would add the delicate touches of sentiment with a dash of his thumb.'" See Stirling's *Annals of the Artists of Spain,* 2nd ed., vol. 4, pp. 176–78.

13. Yriarte, quoted and translated in Glendinning, *Goya and His Critics,* p. 89. The author's remarks are worth quoting in context: "on sera peut-être surpris, en France, de voir la prodigieuse variété de son oeuvre; on l'a rêvé fougueux, rapide, fiévreux, brutal, et il se révélera tout d'un coup fin et précieux comme nos jolis maîtres français du dernier siècle." See Charles Yriarte, *Goya: Sa Biographie, les fresques, les toiles, les tapisseries, les eaux-fortes et le catalogue de l'oeuvre avec cinquante planches inédites d'après les copies de Tabar, Bocourt et Ch. Yriarte* (Paris, 1867), p. 5.

14. See Denys Sutton, ed., *Letters of Roger Fry* (New York, 1972), vol. 1, p. 247.

15. [Roger Fry], "Principal Accessions: Portrait of Don Sebastian Martinez, by Goya," *MMA Bulletin* 1, no. 5 (April 1906), p. 73, ill. facing p. 72; see also R[oger] E. Fry, "Some Recent Acquisitions of the Metropolitan Museum, New York," *Burlington Magazine* 9 (1906), p. 141.

16. [Roger Fry], "Rearrangement of a Picture Gallery at the Museum," *MMA Bulletin* 1, no. 5 (April 1906), p. 69. For a list of the pictures selected for Fry's "Temporary Exhibition in Gallery 24," see Sutton, *Letters of Fry,* vol. 1, p. 255, letter 177, n. 1.

17. See Frances Spalding, *Roger Fry: Art and Life* (Berkeley and Los Angeles, 1980), p. 91.

18. See Sutton, Introduction, *Letters of Fry,* vol. 1, pp. 25–26.

19. See Noel Stock, *The Life of Ezra Pound* (San Francisco, 1982), p. 90.

20. Ezra Pound, *Guide to Kulchur* (London, 1938), p. 114.

21. See Glendinning, *Goya and His Critics,* p. 116.

22. Kenyon Cox, "Workmanship," *MMA Bulletin* 12, no. 7 (July 1917), p. 150.

23. Editorial in the *Evening Post,* April 25, 1906, quoted by Sutton, in *Letters of Fry,* vol. 1, p. 26.

24. A. B. D'H., "Recent Loans of Paintings," *MMA Bulletin* 5, no. 7 (July 1910), p. 172.

25. Ibid.

26. "Recent Loans," *MMA Bulletin* 3, no. 8 (August 1908), p. 164.

27. Bryson Burroughs, "The Paintings," in *The Theodore M. Davis Bequest,* section 2 of *MMA Bulletin* 26, no. 3 (March 1931), p. 15.

According to Goya's own account, in the spring of 1800, he made ten oil studies of the principal members of the royal family in preparation for his large group portrait *Family of Carlos IV* (fig. 10). Only five are known and uncontested; these are the bust-length portraits, dynamical-

ly brushed in over a red-brown ground, that are in the Prado. Though a number of portraits representing members of the royal family had been considered candidates for "lost" oil sketches, most are now regarded as copies modeled after them.

Owing to the persuasive handling of the faces in the Metropolitan's *María Luisa and Her Son,* it had, until recently, been tentatively attributed to Goya. However, there is no evidence to support the idea that this canvas was originally a sketch (like the five in the Prado) which had been carried further by someone else. Like the Metropolitan's *Ferdinand VII,* it too seems to be based on one of Goya's oil studies for the large group portrait. The progressive weakening of both compositions—the heads being the most convincingly painted and the costumes ineffectively translated (and in the case of the *Ferdinand* entirely reinterpreted along with the pose)—strongly suggests that the models for these two works were the head-and-shoulder preparatory studies by Goya; for the remainder of the compositions (witness the clumsy handling of the infant's gown, for example) another artist was left to his own devices.

It is likely that these and other portraits of the same ilk (see G.-W. 788, 790–92) originated as commissions in Goya's studio, perhaps with his participation or under his supervision. At present, too little is known about Goya's colleagues and pupils to attribute the Museum's examples to his workshop. Alternatively, the problem with calling them "copies" is that we can only postulate the works on which our pictures are based. Goya's original sketches for María Luisa (who stands at the far right of the group portrait) and for the future heir to the throne (second from left) are not known.

The source for the Museum's other royal portrait, *María Luisa of Parma, Queen of Spain,* can be established. It is one of several three-quarter-length copies, of varying quality, after Goya's full-length portrait of the queen in court dress of 1800, now in the Palacio Real, Madrid (see G.-W. 781). It has long been recognized as an inferior and later copy.

28. [Bryson Burroughs], "Pictures Lent for the Fiftieth Anniversary Exhibition," *MMA Bulletin* 15, no. 8 (August 1920), p. 190. The *Portrait of Victor Guye* is now in the National Gallery of Art, Washington, D.C.

29. The portraits, received through the bequest of Harry Payne Bingham in 1955, were periodically lent to his widow until her death in 1986.

30. Christian Brinton, "Goyas and Certain Goyas in America," *Art in America* 3 (April 1915), pp. 88 and 97.

31. W[illiam] M. I[vins], Jr., "Five Years in the Department of Prints," *MMA Bulletin* 16, no. 12 (December 1921), p. 260.

32. W[illiam] M. I[vins], Jr., "Goya's Caprices," *MMA Bulletin* 13, no. 7 (July 1918), p. 162.

33. William M. Ivins, Jr., "A Goya Exhibition," *MMA Bulletin* 23, no. 10 (October 1928), p. 232.

34. During Ivins's tenure as curator, from 1916 to 1946, eight exhibitions of Goya's graphic art were mounted in the Print Room, and his prints were regularly featured in other installations.

35. Ivins, "A Goya Exhibition" (see note 33), p. 230.

36. W. M. I., Jr., "Goya's Caprices" (see note 32), p. 162; and "Etchings in the Print Galleries," *MMA Bulletin* 15, no. 7 (July 1920), p. 167.

37. W[illiam] M. I[vins], Jr., "Goya's Disasters of War," *MMA Bulletin* 19, no. 9 (September 1924), pp. 220–24.

38. B[ryson] B[urroughs], "Drawings among the Recent Accessions," *MMA Bulletin* 14, no. 8 (August 1919), p. 178, ill. p. 177.

39. B[ryson] B[urroughs], "A Bull Fight by Goya," *MMA Bulletin* 18, no. 3 (March 1923), pp. 64, 66.

40. "Recommendation for Purchase" papers submitted by Burroughs to the director and the Committee on Purchases on November 14, 1922, MMA Archives. Burroughs had first recommended the purchase in May, but it had been turned down because of price. In the interim Burroughs campaigned committee members to support the purchase and encouraged the owner to lower the purchase price. The acquisition was approved on November 20, 1922.

41. MMA, *Guide to the Collections* (New York, 1924), p. 59 (Gallery 19); the portraits were installed in the Spanish Paintings Gallery (Gallery 28).

42. Bryson Burroughs, Introduction, *Catalogue of an Exhibition of Spanish Paintings from El Greco to Goya,* MMA (New York, 1928), p. xxiv.

43. Ibid., pp. xxiii–xxiv. Having noted this deficiency, Burroughs directed "those who seek figure compositions by Goya" to the Hispanic Society, where they would find "a sketch for his Third of May in the Prado" (no longer attributed to Goya, and curiously the only picture he recommended seeing there). He also added, "For the fantastical and purely imaginative and satirical aspects of his art one must consult his etchings and lithographs, which can be seen in our Department of Prints."

44. Bryson Burroughs, "Spanish Paintings from El Greco to Goya," *MMA Bulletin* 23, no. 2 (February 1928), pp. 39, 42.

45. Quoted from a letter written by Mary Cassatt to Louisine Havemeyer, February 22, 1910, cited in Susan Alyson Stein, "Chronology," in *Splendid Legacy: The Havemeyer Collection,* MMA (New York, 1993), p. 253; regarding code names, also a necessary precaution in terms of the exporting of works from Italy, see pp. 251f.

46. On this subject, see Louisine W. Havemeyer, *Sixteen to Sixty: Memoirs of a Collector,* ed. by Susan Alyson Stein (New York, 1993), pp. 136–37, 176, 178; and Stein, in *Splendid Legacy,* pp. 252–53, 255, 262.

47. "An Interview of A. Hyatt Mayor," *Archives of American Art Journal* 18, no. 4 (1978), p. 10.

48. The Goyaesque *City on a Rock* (29.100.12) has the distinction of having been owned by an American dealer and collector by the mid-1880s, when it was acquired in Spain by James S. Inglis. Mrs. Havemeyer bought it from his estate through Cottier and Co., New York, in 1912.

 This canvas, which may have been made as late as 1875–80, is an inventive pastiche. It freely combines compositional motifs taken from autograph paintings and prints by Goya (e.g., the "black paintings" and the *Disparates*) with a rigorous and harsh style of execution that is very much in keeping with late-nineteenth-century notions of Goya's "mortared" technique. On this subject, see Janis Tomlinson, *Francisco Goya y Lucientes, 1746–1828* (London, 1994), p. 299.

49. Brinton, "Goya and Certain Goyas in America" (see note 30), p. 88.

50. The attribution to Goya of the Museum's portrait of Iriarte was first challenged in 1953 when it was shown side by side with the Strasbourg portrait in a "Goya" exhibition at Basel, Switzerland. Nearly identical in size and composition but painted with considerably less verve and fluency, it did not hold up well by comparison. The Museum's version appeared appreciably stiffer, blander, less animated. Goya is not known to have made replicas, and the inscription at the bottom of the portrait does not correspond to his handwriting.

51. "Recommendation for Purchase" papers submitted by Burroughs to the director and the Committee on Purchases on November 14, 1922, MMA Archives.

52. Burroughs noted that of the double bullrings "such as that shown on our canvas," the "only other example in Goya's work occurs in one of the late lithographs, Les Taureaux de Bordeaux" (see fig. 20), and he found that of the paintings, the "one in the Academy of San Fernando, Madrid, . . . has analogies to the example we have acquired." B. B., "A Bull Fight by Goya" (see note 39), p. 66.

 The Museum's painting is close in conception and style to the celebrated *Bullfight in a Village* in Madrid and was, until recently, thought to be an earlier version, ca. 1810–12. It is painted on a reused canvas (X rays show, underneath, a coat of arms of the seventeenth–eighteenth century on which the artist overpainted his preparatory orange ground); this is characteristic of other paintings made during the war when canvas was in short supply. Documentary evidence suggests that it was included in the inventories of Goya's studio made in 1812 and 1828. (These documents, however, are being critically studied and their relevance to questions of authenticity reevaluated.) By 1867, the Museum's *Bullfight* belonged to Madrid banker and art collector José de Salamanca, who owned pictures by Goya as well as copies after his works, including a version of *Majas on a Balcony* by Leonardo Alenza y Nieto (1807–1845). Salamanca was the great patron of Eugenio Lucas y Padilla (1824–1870), who specialized in Goyaesque bullfights.

 Most scholars consider the execution of the Museum's *Bullfight* so weak as to preclude the possibility of its being authentic. The artist seems to have imitated the style of the genuine painting in Madrid by resorting to a kind of paint-by-numbers approach. The figures here are outlined in black and then accented with color, while Goya always closely knit his line and color to model his forms and give them substance. The buildings in the distance, softly brushed by Goya, are here crude blocks of paint, and the spectators, suggested by Goya's deft, comma-like strokes of paint and well-placed highlights, are here a muddled mess. Conspicuous underdrawing, which contributes to the sketchy quality of the Museum's work and led early cataloguers to consider it "unfinished," significantly does not relate to any of the figure groupings. Ultimately the stick-figure bullfighters and *chulos,* the lumpy bulls and flimsy horses are simply too feebly drawn to be by the author of the *Tauromaquia* and the *Bulls of Bordeaux.*

53. The opinions of Dr. August L. Mayer on these two works and other Spanish paintings in the Museum's collection are recorded in a memorandum of March 11, 1914, Department of European Paintings archives, MMA. Of the "Goya, Jewess of Tangiers," he remarked, "do not know by whom; not by Goya"; of the "Goya, Sketch for Capricho," he remarked, "not by Goya." See August L. Mayer, *Francisco de Goya,* trans. by Robert West (London and Toronto, 1924).

54. "Greco and Goya Owners," *American Art News* 13 (January 30, 1915), p. 1.

55. Havemeyer, *Sixteen to Sixty* (1993), p. 166.

56. Ibid., pp. 158–59.

57. Ibid., p. 154. In her memoirs, Mrs. Havemeyer often lamented how dealers had "bought and boomed Goyas" (*Sixteen to Sixty* [1993], p. 133) and had "turned the heads of the Spaniards about their Goyas" (pp. 136–37).

58. For documentation, see Havemeyer, *Sixteen to Sixty* (1993), pp. 130–39, 322–27; and Stein, in *Splendid Legacy,* pp. 222f.

59. On the subject of the Havemeyers' Goya collection, see Gary Tinterow, "The Havemeyer Pictures," *Splendid Legacy,* pp. 13–17.

60. Havemeyer, *Sixteen to Sixty* (1993), p. 163.

61. Ibid., p. 167.

62. Ibid.

63. For other revealing differences between the two versions, see Gary Tinterow, in *Splendid Legacy*, pp. 15–16.

64. [Harry B. Wehle], "The Exhibition of the Havemeyer Collection: Paintings," *MMA Bulletin* 25, no. 3 (March 1930), pp. 58–60.

65. Havemeyer, *Sixteen to Sixty* (1993), p. 177.

 The painting is still tentatively attributed to Goya, although doubts have been raised regarding its authenticity (see G.-W., note to 889, p. 253), and its provenance prior to 1900 is unknown. Even Gudiol, who accepted it as by Goya, described the portrait as "pretentious" and "artificial" (José Gudiol, *Goya, 1746–1828: Biography, Analytical Study, and Catalogue of His Paintings,* trans. by Kenneth Lyons [New York, 1971], vol. 1, p. 132). It seems almost certainly a pastiche. A seated woman shown half or three-quarter length, her hands folded in her lap and holding a fan, is of a type well established in Goya's oeuvre (two were recorded, for example, in the 1828 inventory of the artist's estate). The pose and costume closely mimic that of the seated maja in one of Goya's *Caprichos,* plate 15, *Bellos consejos;* the rose pinned at her bodice may be traced to the *Marquesa de Villafranca* (Prado), the elaborate bow to the *Marquesa de la Solana* (Louvre), and the signature-ring to the equally famous *Duchess of Alba* (Hispanic Society, New York). (Ironically, the last two allusions are to celebrated portraits that the Havemeyers declined to buy.)

66. Havemeyer, *Sixteen to Sixty* (1993), p. 163.

67. Regarding doubts raised at the time of sale, see Stein, in *Splendid Legacy*, p. 260.

68. Extract from Friedsam's will of June 13, 1930, Department of European Paintings archives, MMA.

69. Calvin Tomkins, *Merchants and Masterpieces: The Story of the Metropolitan Museum of Art* (New York, 1970), p. 234.

70. Minutes of the Board of Trustees, May 15, 1933, MMA Archives.

71. H. E. Winlock, letter to John S. Burke, February 6, 1934, MMA Archives.

72. The various lists, documents, and correspondence concerning this bequest are preserved in the MMA Archives and in the Department of European Paintings archives, MMA.

73. J. M. L., "Paintings Galleries," *MMA Bulletin* 30, no. 1 (January 1935), p. 20.

74. Burroughs, "The Paintings" (see note 27), p. 15.

75. Robert de Forest is quoted in a memorandum of September 15, 1930, issued to curators by Director Edward Robinson, Department of European Paintings archives, MMA.

76. Claude Monet's *Valley of the Nervia* (30.95.251) and *Seine at Vétheuil* (30.95.271) were slated to be sold, but not *Rouen Cathedral* (30.95.250). Various lists and other documents concerning the estate of Theodore M. Davis are preserved in the Department of European Paintings archives, MMA.

77. Harry B. Wehle, "Recommendation for Purchase" papers submitted to the director and the Committee on Purchases on August 29, 1935, MMA Archives.

78. Correspondence and other documents regarding the acquisition of the album of drawings are preserved in MMA Archives.

79. Harry B. Wehle, *Fifty Drawings by Francisco Goya,* MMA Papers, no. 7 (New York, 1938).

80. Ivins had originally been contacted about the album of drawings, but he seems to have been away from the Museum during the summer of 1935. When he learned that Blumenthal had secured the album, he wrote Wehle that he was "delighted about the drawings," and on the purchase papers submitted by Wehle in August 1935, he added his endorsement in the form of a handwritten note: "If I may be permitted to say so I am in the heartiest favor of this purchase and regard it as a very great opportunity of the greatest importance" (MMA Archives).

81. Ivins, "A Goya Exhibition" (see note 33), p. 230.

82. "An Exhibition of the Work of Goya" (see note 2).

83. A. Hyatt Mayor, "Goya's Giant," *MMA Bulletin* 30, no. 8 (August 1935), p. 154.

84. Michael Kimmelman, "At the Met with Roy Lichtenstein: Disciple of Color and Line, Master of Irony," *New York Times,* March 31, 1995, p. C27.

85. See Wehle, *Catalogue of . . . Paintings* (1940), pp. 253–54.

86. "An Exhibition of the Work of Goya" (see note 2), p. 22.

87. Ibid.

88. Everett Fahy, "Outstanding Recent Accessions—European Paintings: Goya's Portrait of Pepito Costa y Bonells," *MMA Bulletin,* n.s. 31, no. 4 (Summer 1973), p. 174. The donor's life interest in this gift was relinquished in 1972.

89. Theodore Rousseau, Jr., "A Guide to the Picture Galleries," *MMA Bulletin,* n.s. 12, no. 5, pt. 2 (January 1954), pp. 1, 5–6.

90. See Milton W. Brown, *The Story of the Armory Show,* 2nd ed. (New York, 1988), pp. 44, 112, 116.

91. Burroughs, in *Catalogue of an Exhibition of Spanish Paintings from El Greco to Goya,* p. xxiv.

Majas on a Balcony:

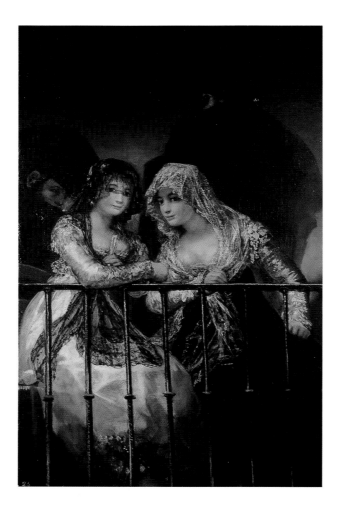

FIGURE 42

Majas on a Balcony, 1808–12. Oil on canvas, 63⅞ x 42⅛ in. (162 x 107 cm).
PRIVATE COLLECTION

There has never been any dispute over the authenticity of this work. First recorded in Goya's inventory of 1812, later owned by the king of France and the Montpensier family of Spain, it has been in the possession of the family of the present owner for three generations. It is a painting of unchallenged integrity and is universally regarded as one of the masterpieces of Goya's career.

Is the Museum's Painting by Goya?

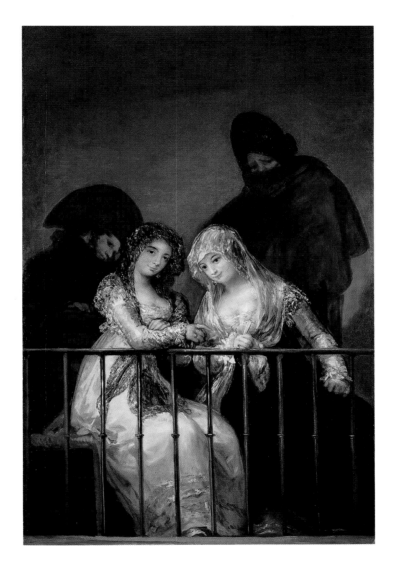

FIGURE 43

Attributed to Goya, *Majas on a Balcony.* Oil on canvas, 76¾ x 49½ in. (194.9 x 125.7 cm).
H. O. HAVEMEYER COLLECTION, BEQUEST OF MRS. H. O. HAVEMEYER, 1929 (29.100.10)

Can the Metropolitan Museum's *Majas on a Balcony* still be regarded, as it has been since the mid-nineteenth century, as an autograph painting by Goya? Or is it a variant made after the artist's death by an adroit copyist? Recognizing that the opportunity to compare these two paintings side by side might put to rest this debate, the owner of the magisterial *Majas on a Balcony* at left has agreed to lend it to the Metropolitan's exhibition this fall.

Summary of the Debate

Detractors of the Museum's *Majas* point to the fact that, whereas almost all of Goya's undisputed canvases were recorded during his lifetime in one manner or another, this painting is first documented only in 1835—that is, seven years after Goya's death and, conveniently, the year before the undisputed version was purchased for the Spanish Gallery of King Louis-Philippe from Goya's son, Javier, who was a painter in his own right. As the property of the Infante Don Sebastián Maria Gabriel de Borbón y Braganza, the Museum's painting was prominently displayed in Madrid, becoming well known, copied, and photographed, although in 1868 one photographer listed it as a "copy" after the more famous version then in France.

Subsequent restorations have falsified the visual information—much of the original surface has been lost, denying an accurate appraisal of its original appearance. Modern conservators have made the painting look more like an authentic Goya, but detractors feel that the author of the Metropolitan's picture misunderstood the knowing exchange between the majas that takes place in the original painting. Furthermore, the Museum's painting has all the hallmarks of a copy: the balcony was painted first, and the dresses only fitted in afterward (unlike the undisputed version, in which the dresses were painted first and the balcony added with a few sure touches afterward); the thin, watercolor-like painting of the flesh is not like that of any period of Goya's career; and the painting of the silks and lace—which, unlike the other painting, does not actually re-create the patterns of the lace—is clumsy and crude. The extensive use of the palette knife is a sure sign of Goya's imitators, who emulated his bravura technique without his success at reproducing the illusion of actual textures, which was Goya's great gift.

Detractors point as well to the canvas, which is not typical of those Goya used. The uncontested *Majas* and two related compositions—*Maja and Celestina* (Juan March Foundation) and the *Old Crones* (Musée des Beaux-Arts, Lille)—are painted on old, reused canvases, whereas the Metropolitan canvas was fresh and smooth, with no telltale signs of previous work.

Lastly, with the exception of important portrait commissions, which are all documented, there are no examples in Goya's long career of the artist duplicating, at approximately the same size, a painting he had already developed. He was too fecund an artist to repeat himself.

Supporters of the painting point to the fact that nothing is known of the early history of the Metropolitan's painting that would contradict Goya's authorship. It emerged only seven years after the artist's death in an important and conspicuous Spanish collection and became well known throughout the nineteenth century as a variant of the painting in Louis-Philippe's collection in France. It spawned, like that version, numerous copies and imitations. And it has been accepted by almost all of the cataloguers of Goya's art until quite recently.

Supporters argue that since the painting has suffered damage and several restorations, it is impossible to say with authority that it is not by Goya, and they ask who else could have made such an impressive work? It is essential to distinguish Goya's original barely laid-in sketch, which includes only the two majas and the head and bust of the cloaked figure at left, from later additions and repainting. This principal group was thinly, quickly, assuredly painted without hesitation and without any detectable underdrawing. Palette-knife technique is particularly difficult, and no other artist is known who could use a knife as confidently as the author of the Metropolitan canvas. The painting thus could be an original work by Goya, perhaps intended as a decoration, that was left unfinished in his studio.

Checklist of the Museum's Paintings, Drawings, and Prints by Goya

Figure numbers at the end of entries refer to illustrations in this catalogue. Numbers preceded by G.-W., G., H., or D. are catalogue raisonné listings; citations are given in the Selected Bibliography.

PAINTINGS

FRANCISCO DE GOYA
Y LUCIENTES (1746–1828)

The Countess of Altamira
(María Ygnazia Álvarez, died 1795)
and Her Daughter (María Agustina
Osoria Álvarez, born 1787)
Oil on canvas, 76½ x 45¼ in.
(194.3 x 114.9 cm)
Inscribed (bottom): LA EX.^ma S.^a D.^a
MARIA YGNACIA ALVAREZ DE TOLEDO
MARQVESA DE ASTORGA CONDESA DE
ALTAMIRA / Y. LA S. D. MARIA AGVSTINA
OSORIO ALVAREZ DE TOLEDO SV HIJA .
NACIO . EN 21 DE FEBRERO DE 1787.
(Her Excellency the Lady María
Ygnacia Álvarez of Toledo, marchioness
of Astorga and countess of Altamira,
and the Lady María Agustina Osoria
Álvarez of Toledo, her daughter, born
February 21, 1787.)
G.-W. 232
ROBERT LEHMAN COLLECTION, 1975
1975.1.148 *(fig. 5)*

Don Manuel Osorio Manrique de Zuñiga
(1784–1792)
Oil on canvas, 50 x 40 in.
(127 x 101.6 cm)

Signed and inscribed: (on card in bird's
beak) D^n Fran^co Goya; (bottom) EL S^r.
D^n. MANVEL OSORIO MANRRIQUE DE
ZVÑIGA S^r DE BINES NACIO EN ABR A II
DE 1784 (Señor Don Manuel Osorio
Manrique de Zuñiga, señor of Ginés
[Canary Islands], born on April 2, 1784)
G.-W. 233
THE JULES BACHE COLLECTION, 1949
49.7.41 *(fig. 1)*

Don Sebastián Martínez y Pérez
(1747–1800)
Oil on canvas, 36⅝ x 26⅝ in.
(93 x 67.6 cm)
Signed, dated, and inscribed (on letter):
D^n Sebastian / Martinez / Por su
Amigo / Goya / 1792 (Don Sebastián
Martínez by his friend Goya 1792)
G.-W. 333
ROGERS FUND, 1906
06.289 *(fig. 23)*

Doña Josefa Castilla Portugal de Garcini
Oil on canvas, 41 x 32⅜ in.
(104.1 x 82.2 cm)
Signed, dated, and inscribed (lower
right): D^a Josefa Castilla. de / Garcini.
p^r Goya. 1804
G.-W. 821
BEQUEST OF HARRY PAYNE BINGHAM,
1955
55.145.2 *(fig. 12)*

Don Ignacio Garcini y Queralt,
Brigadier of Engineers
(1770–1825)
Pendant to 55.145.2
Oil on canvas, 41 x 32¾ in.
(104.1 x 83.2 cm)

Signed, dated, and inscribed
(lower left): D^n. Ignacio Garcini / por
Goya. 1804.
G.-W. 820
BEQUEST OF HARRY PAYNE BINGHAM,
1955
55.145.1 *(fig. 11)*

José Costa y Bonells (died 1870),
called Pepito
Oil on canvas, 41⅜ x 33¼ in.
(105.1 x 84.5 cm)
Signed, dated, and inscribed (lower
left): Pepito Costa y Bonells / Por
Goya. 18[]
G.-W. 895
GIFT OF COUNTESS BISMARCK, 1961
61.259 *(fig. 37)*

Don Tiburcio Pérez y Cuervo,
the Architect
Oil on canvas, 40¼ x 32 in.
(102.2 x 81.3 cm)
Signed, dated, and inscribed (lower
left): A Tiburcio Perez / Goya. 1.820.
G.-W. 1630
THEODORE M. DAVIS COLLECTION,
BEQUEST OF THEODORE M. DAVIS, 1915
30.95.242 *(fig. 18)*

ATTRIBUTED TO GOYA

Doña Narcisa Barañana de Goicoechea
Oil on canvas, 44¼ x 30¾ in.
(112.4 x 78.1 cm)
Signed (on ring): Goya
G.-W. 889
H. O. HAVEMEYER COLLECTION, BEQUEST
OF MRS. H. O. HAVEMEYER, 1929
29.100.180 *(fig. 29)*

Majas on a Balcony
Oil on canvas, 76¾ x 49½ in.
(194.9 x 125.7 cm)
G.-W. 960
H. O. HAVEMEYER COLLECTION, BEQUEST
OF MRS. H. O. HAVEMEYER, 1929
29.100.10 (*fig. 43*)

COPIES AFTER GOYA

Spanish, 1797 or later
Don Bernardo de Iriarte (1734–1814)
Oil on canvas, 42½ x 33½ in.
(108 x 85.1 cm)
Inscribed (bottom): D.ⁿ Bernardo Yriarte,
Vice-prot.ʳ de la R.ˡ Academia de las / tres
nobles Artes, retratado por Goya entesti-
monio de mu- / tua estimac.ⁿ y afecto año
de 1797 (Don Bernardo Yriarte, vice
protector of the Royal Academy of Fine
Arts, portrayed by Goya in testimony of
mutual esteem and affection, [in] the
year 1797)
Cited in G.-W. under note for 669
BEQUEST OF MARY STILLMAN HARKNESS,
1950
50.145.19

Spanish, 1800 or shortly after
Infanta María Luisa (1782–1824) *and
Her Son Don Carlos Luis* (1799–1883)
Oil on canvas, 39⅛ x 27 in.
(99.4 x 68.6 cm)
Not in G.-W.
THEODORE M. DAVIS COLLECTION,
BEQUEST OF THEODORE M. DAVIS,
1915
30.95.243 (*fig. 24*)

Spanish, 1800 or shortly after
Ferdinand VII (1784–1833),
When Prince of Asturias
Oil on canvas, 32¾ x 26¼ in.
(83.2 x 66.7 cm)
G.-W. 791
GIFT OF RENÉ FRIBOURG, 1951
51.70

Spanish, after 1800
María Luisa of Parma (1751–1819),
Queen of Spain
Oil on canvas, 43½ x 33½ in.
(110.5 x 85.1 cm)
Cited in G.-W. under note for 781
H. O. HAVEMEYER COLLECTION, BEQUEST
OF MRS. H. O. HAVEMEYER, 1929
29.100.11 (*fig. 30*)

STYLE OF GOYA

Spanish, early 19th century
Bullfight in a Divided Ring
Oil on canvas, 38¾ x 49¾ in.
(98.4 x 126.4 cm)
G.-W. 953
CATHARINE LORILLARD WOLFE
COLLECTION, WOLFE FUND, 1922
22.181 (*fig. 26*)

Spanish, 19th century
A City on a Rock
Oil on canvas, 33 x 41 in.
(83.8 x 104.1 cm)
G.-W. 955
H. O. HAVEMEYER COLLECTION, BEQUEST
OF MRS. H. O. HAVEMEYER, 1929
29.100.12 (*fig. 28*)

ATTRIBUTED TO
GASPARE TRAVERSI

Italian, Neapolitan (ca. 1722–1770)

Portrait of a Man
Oil on canvas, 22 x 17½ in.
(55.9 x 44.5 cm)
Inscribed (falsely, right center): Goya /
1780
H. O. HAVEMEYER COLLECTION, BEQUEST
OF MRS. H. O. HAVEMEYER, 1929
29.100.179 (*fig. 31*)

DRAWINGS

The fifty drawings with accession numbers
35.103.1–50 were acquired en bloc, and
when purchased were pasted onto the
rose-colored pages of a scrapbook appar-
ently assembled by Goya's son Javier from
the contents of four of his father's drawing
albums. The artist's grandson, Mariano,
probably sold the clothbound volume to
the Spanish painter Valentín Carderera
sometime after 1854. It was later pur-
chased by Federico Madrazo (1815–
1894), Spanish painter and connoisseur,
who in the year of his death, sent it as a
gift to his grandson. It was from this heir,
Mariano Fortuny y Madrazo (son of the
painter Mariano Fortuny), that the
Metropolitan Museum bought the group
in 1935, after Fortuny sent it from his
home in Venice to an exhibition at the
Bibliothèque Nationale in Paris, where
the Louvre also vied for its purchase (see
Harry B. Wehle, *Fifty Drawings by
Francisco Goya*, MMA Papers, no. 7 [New
York, 1938]).
 Titles of the drawings are descrip-
tive, except where Goya supplied the
title—by inscription on the drawing, or
in the legend of a related etching.

Self-Portrait in a Cocked Hat, ca. 1790–92
Pen and brown ink; 98 x 88 mm
G. II, 319
ROBERT LEHMAN COLLECTION, 1975
1975.1.976 (*fig. 34*)

Self-Portrait, ca. 1795–1800
Brush and gray wash; 152 x 91 mm
Signed on the lapel jewel: *Goya*
G. II, 331
HARRIS BRISBANE DICK FUND, 1935
35.103.1 (*frontispiece*)

Self-Portrait, ca. 1797–98
Red chalk; 200 x 143 mm
Verso: *Sketches for a Self-Portrait*
Red chalk with touches of pen and
black ink
G. II, 66 and 67
BEQUEST OF WALTER C. BAKER, 1971
1972.118.295 (*fig. 44*)

DRAWINGS FROM ALBUM B
("Madrid Album"), 1796–97

Weeping Woman and Three Men
Album B, page 17
Brush and gray wash; 235 x 146 mm
Verso: *A Maja and Two Companions*
Album B, page 18
Brush and gray wash
G. I, 32 and 33
HARRIS BRISBANE DICK FUND, 1935
35.103.4, 5

The Swing
Album B, page 21
Brush and gray wash; 237 x 146 mm
Verso: *Maja and an Officer*
Album B, page 22
Brush and gray wash
G. I, 36 and 37
HARRIS BRISBANE DICK FUND, 1935
35.103.2, 3 (*fig. 6*)

A Young Woman and a Bull
Album B, page 23
Brush and gray wash; 235 x 146 mm
Verso: *Lovers Sitting on a Rock*
Album B, page 24
Brush and gray wash
G. I, 38 and 39
HARRIS BRISBANE DICK FUND, 1935
35.103.7, 6

Three Washerwomen
Album B, page 45
Brush and gray wash; 235 x 146 mm
Verso: *A Young Woman at a Well*
Album B, page 46
Brush and gray wash
G. I, 56 and 57
HARRIS BRISBANE DICK FUND, 1935
35.103.8, 9

They Are Getting Drunk
Album B, page 67
Brush and gray wash; 235 x 146 mm
Inscribed in brush and gray wash,
below the image: *se emborrachan*
Verso: Study for *Capricho,* plate 33,
Al Conde Palatino (At the Count Palatine's)
Album B, page 68
Brush and gray wash
Inscribed in brush and wash (with
pen and ink corrections), above and
below the image: *Tuto parola e busia /
el charlatan qe. arranca una quijada y lo /
creen.* (Every word is a lie; the Charlatan
pulls out a jawbone and they believe it.)
G. I, 72 and 73

HARRIS BRISBANE DICK FUND, 1935
35.103.11, 10

Humility versus Pride
Album B, page 75
Brush and gray wash; 235 x 146 mm
Inscribed in brush and wash, below the
image: *Humildad* [sic] *contra soberbia*
Verso: *Generosity versus Greed*
Album B, page 76
Brush and gray wash
Inscribed in brush and wash (with
correction in pen and ink), below the
image: *Largueza contra Abaricia*
G. I, 78 and 79
HARRIS BRISBANE DICK FUND, 1935
35.103.13, 12

Family Vengeance
Album B, page 77
Brush and gray wash; 235 x 146 mm
Inscribed in brush and wash (with cor-
rections in pen and ink), below the
image: *Los hermanos de ella, matan a su
amante, y ella / se mata despues*
(Her brothers kill her lover, and
afterward she kills herself)
Verso: *They Got the Confessor to
Climb in by the Window*
Album B, page 78
Brush and gray wash
Inscribed in pen and ink, below the
image: *An echo subir al confesor por la
bentana*
G. I, 80 and 81
HARRIS BRISBANE DICK FUND, 1935
35.103.14, 15

Masquerading Asses
Album B, page 93
Brush with gray and black wash,
touched with pen and brown ink;
235 x 146 mm
Inscribed in pen and ink, above and
below the image: *Conocelos el aceitero y
dice ¿Ola? y empieza / a palos con las
mascaras // ellos huyendo, claman la
injusticia del poco respeto / a su representa-
cion* (The oil vendor recognizes them and
cries "Hey!" and begins to beat the
masqueraders; fleeing, they protest the
injustice of such disrespect for their
performance)
Verso: *The Tantrum*
Album B, page 94
Brush and gray wash
Inscribed in pen and ink, above and
below the image: *Manda qe. quiten el
coche, se despeina, y / arranca el pelo y
patéa // Porqe. el abate Pichurris, le a
dicho en sus ocios, qe. / estaba descolorida*
(She orders them to leave the carriage,
musses her hair, tears at it, and stamps,
all because Father Pichurris told her to
her face that she looked pale)
G. I, 94 and 95
HARRIS BRISBANE DICK FUND, 1935
35.103.17, 16

DRAWINGS FROM ALBUM D
("Unfinished Album"), 1801–3

Nothing Is Known of This
Album D, page 7
Brush with black and gray wash;
236 x 147 mm
Inscribed in brush and wash, below
the image: *De esto nada se sabe*
G. I, 99
HARRIS BRISBANE DICK FUND, 1935
35.103.24

He Wakes Up Kicking
Album D, page 13
Brush and gray wash; 236 x 146 mm
Inscribed in black chalk, below the
image: *Dispierta dando patadas*
G. I, 101
HARRIS BRISBANE DICK FUND, 1935
35.103.26

Nightmare
Album D, page 20
Brush with black ink and gray wash;
233 x 144 mm
Inscribed in black chalk, below the
image: *Vision* (crossed out) *Pesadilla*
G. I, 104
Ex coll.: Eugène Rodrigues (Lugt 897)
ROGERS FUND, 1919
19.27 *(fig. 9)*

Unholy Union
Album D(?)
Brush with black ink and wash;
176 x 127 mm
G. I, 112
ROBERT LEHMAN COLLECTION, 1975
1975.1.975

DRAWINGS FROM ALBUM E
("Black Border Album"), 1806–17

You'll See Later
Album E, page 24
Brush with black and gray wash;
267 x 187 mm
Inscribed in ink, below image:
Despues lo beras
G. I, 125
HARRIS BRISBANE DICK FUND, 1935
35.103.18

God Save Us from Such a Bitter Fate
Album E, page 41
Brush with black ink and wash;
268 x 188 mm
Inscribed in graphite, lower margin:
Dios nos libre de tan amargo lance
G. I, 136
HARRIS BRISBANE DICK FUND, 1935
35.103.50 *(fig. 13)*

DRAWINGS FROM ALBUM F
("Sepia Album"), 1812–23

Crowd in a Park
Album F, page 31
Brush and brown wash; 206 x 143 mm
G. I, 302
HARRIS BRISBANE DICK FUND, 1935
35.103.19

A Nude Woman Seated Beside a Brook
Album F, page 32(?)
Brush and brown wash; 206 x 143 mm
G. I, 303
HARRIS BRISBANE DICK FUND, 1935
35.103.25

Monks in an Interior
Album F, page 33
Brush and brown wash; 205 x 143 mm
G. I, 304
HARRIS BRISBANE DICK FUND, 1935
35.103.20

A Man and a Woman on a Mule
Album F, page 36
Brush and brown wash; 205 x 143 mm
G. I, 306
HARRIS BRISBANE DICK FUND, 1935
35.103.21

Hunting Lice
Album F, page 40
Brush and brown wash; 205 x 146 mm
G. I, 310
HARRIS BRISBANE DICK FUND, 1935
35.103.27

Interior of a Church
Album F, page 41
Brush and brown wash; 205 x 143 mm
G. I, 311
HARRIS BRISBANE DICK FUND, 1935
35.103.28

Crowd in a Circle
Album F, page 42
Brush and brown wash; 207 x 143 mm
G. I, 312
HARRIS BRISBANE DICK FUND, 1935
35.103.29

*Constitutional Spain Beset by
Dark Spirits,* 1820–23
Album F, page 45
Brush and brown wash;
205 x 142 mm
G. I, 315
HARRIS BRISBANE DICK FUND, 1935
35.103.30

Construction in Progress
Album F, page 46
Brush with brown and gray-brown
wash; 205 x 143 mm
G. I, 316
HARRIS BRISBANE DICK FUND, 1935
35.103.31

Gravediggers, 1812–20
Album F, page 51
Brush with brown and gray-brown
wash; 206 x 143 mm
G. I, 317
HARRIS BRISBANE DICK FUND, 1935
35.103.32

The Stabbing
Album F, page 53
Brush and brown wash;
205 x 143 mm
G. I, 319
HARRIS BRISBANE DICK FUND, 1935
35.103.33

A Woman Kneeling before an Old Man
Album F, page 55
Brush and brown wash; 205 x 143 mm
G. I, 321
HARRIS BRISBANE DICK FUND, 1935
35.103.34

A Woman Whispering to a Priest
Album F, page 59
Brush and brown wash; 205 x 143 mm
G. I, 325
HARRIS BRISBANE DICK FUND, 1935
35.103.35

A Man Drinking from a Wine Skin
Album F, page 63
Brush and brown wash;
205 x 143 mm
G. I, 329
HARRIS BRISBANE DICK FUND, 1935
35.103.36

A Nun Frightened by a Ghost
Album F, page 65
Brush and brown wash; 205 x 145 mm
G. I, 331
HARRIS BRISBANE DICK FUND, 1935
35.103.37 *(fig. 17)*

Acrobats
Album F, page 67
Brush and brown wash; 205 x 147 mm
G. I, 332
HARRIS BRISBANE DICK FUND, 1935
35.103.38

Beggar with a Staff in His Right Hand
Album F, page 69
Brush and brown wash; 205 x 143 mm
G. I, 333
HARRIS BRISBANE DICK FUND, 1935
35.103.39

Beggar with a Staff in His Left Hand
Album F, page 70
Brush and brown wash; 205 x 143 mm
G. I, 334
HARRIS BRISBANE DICK FUND, 1935
35.103.40

Waking from Sleep in the Open Air
Album F, page 71
Brush and brown wash; 205 x 146 mm

G. I, 335
HARRIS BRISBANE DICK FUND, 1935
35.103.41

A Disheveled Woman with a Group
Album F, page 76
Brush and brown wash; 206 x 145 mm
G. I, 340
HARRIS BRISBANE DICK FUND, 1935
35.103.42

Women with Children by a Wayside Cross
Album F, page 78
Brush and brown wash; 205 x 143 mm
G. I, 341
HARRIS BRISBANE DICK FUND, 1935
35.103.43

Two Prisoners in Irons, 1820–23
Album F, page 80
Brush and brown wash; 206 x 143 mm
G. I, 343
HARRIS BRISBANE DICK FUND, 1935
35.103.44

A Man Interfering in a Street Fight
Album F, page 82
Brush and brown wash; 205 x 143 mm
G. I, 345
HARRIS BRISBANE DICK FUND, 1935
35.103.45

Revenge Upon a Constable
Album F, page 86
Brush and brown wash; 205 x 145 mm
Inscribed in pen and ink: *Muerte del
Alguacil Lampinos, por per / seguidor de
estudiantes, y mugeres de fortuna, / las qe.
le hecharon una labatiba con cal viva*
(Death of Constable Lampinos for his
persecution of students and the women
of the town, who gave him a douche
of quick lime)
G. I, 347
HARRIS BRISBANE DICK FUND, 1935
35.103.49

*A Woman Murdering a
Sleeping Man*
Album F, page 87
Brush and brown wash; 205 x 143 mm
G. I, 348
HARRIS BRISBANE DICK FUND, 1935
35.103.46

Provincial Dance
Album F, page 89
Brush and brown wash; 206 x 143 mm
G. I, 350
HARRIS BRISBANE DICK FUND, 1935
35.103.47

*A Woman Handing a Mug to
an Old Man*
Album F, page 93
Brush and brown wash; 206 x 143 mm
G. I, 353
HARRIS BRISBANE DICK FUND, 1935
35.103.48

Rabbit Hunter with a Retriever
Album F, page 103
Brush and brown wash; 207 x 147 mm
G. I, 360
HARRIS BRISBANE DICK FUND, 1935
35.103.22

Bird Hunters with a Decoy
Album F, page 105
Brush with brown and gray wash;
205 x 147 mm
G. I, 362
HARRIS BRISBANE DICK FUND, 1935
35.103.23

ATTRIBUTED TO GOYA

Prisoners, ca. 1810–20
Brush with brown and black wash
over red chalk; 150 x 92 mm
Verso: A sketch of a monstrous animal
relating to an unpublished plate in the
series *Disasters of War* (H. 201)
Red chalk
See G.-W. 1521a–e and
G. II, 229, 360–64
Ex coll.: Marqués de Casa Torres
BEQUEST OF HARRY G. SPERLING, 1971
1975.131.219

IMITATOR OF GOYA

Hanged Man
Pen with brown ink and brown wash;
178 x 110 mm
BEQUEST OF WALTER C. BAKER, 1971
1972.118.9

PRINTS

INDIVIDUAL ETCHINGS

El ciego de la guitarra
The Blind Guitarist
Working proof, 1778
Etching; 395 x 570 mm
H. 20.I
PURCHASE, ROGERS FUND AND
JACOB H. SCHIFF BEQUEST, 1922
22.63.29 *(fig. 2)*

El agarrotado
The Garroted Man
Working proof, ca. 1778–80
Etching printed in blue ink;
330 x 210 mm
H. 21.I
ROGERS FUND, 1920
20.22 *(fig. 4)*

El agarrotado
The Garroted Man
Third edition, 1868
Etching and burin; 330 x 210 mm
H. 21.III.3
GIFT OF MRS. FRANCIS ORMOND, 1950
50.558.34

Barbara dibersion
Barbarous Entertainment
Etched ca. 1800–1804
Posthumous proof
before first edition of 1867
Etching, aquatint, and drypoint;
175 x 215 mm
H. 25.II
ROGERS FUND, 1918
18.42.2

Tan bárbara la seguridad como el delito
The Custody Is as Barbarous as the
Crime (Prisoner Leaning on His Chains)
Etched ca. 1810–14
Post-edition impression
with letters masked, after 1800
Etching and burin;
110 x 85 mm
H. 26.IV
ROGERS FUND, 1918
18.42.1

Si es delinquente qᵉ. muera presto
If He Is Guilty, Let Him Die Quickly
Etched ca. 1810–14
Posthumous edition made for
John Savile Lumley, 1859
Etching and burin;
115 x 85 mm
H. 28.III
ROGERS FUND, 1918
18.45.2

Giant
Working proof, by 1818
(One of six impressions known)
Burnished aquatint; first state;
285 x 210 mm
H. 29.I
Ex coll.: Georges Prévôt
HARRIS BRISBANE DICK FUND, 1935
35.42 *(fig. 15)*

ETCHINGS AFTER VELÁZQUEZ

Los borrachos
The Drunkards
First edition, 1778
Etching; 315 x 430 mm
H. 4.III.1
HARRIS BRISBANE DICK FUND, 1924
24.97.1

Felipe III. Rey de España
Philip III, King of Spain
First edition, 1778
Etching and drypoint;
370 x 310 mm
H. 5.III.1
GIFT OF NATHAN CHAIKIN, 1960
61.524.1

*D Margarita de Austria Reyna de España,
Muger de Phelipe III*
Margaret of Austria, Queen of Spain
and Wife of Philip III
First edition, 1778
Etching and drypoint; 370 x 310 mm

H. 6.III.1
PURCHASE, ROGERS FUND AND
JACOB H. SCHIFF BEQUEST, 1922
22.60.23

Felipe IV. Rey de España
Philip IV, King of Spain
First edition, 1778
Etching; 370 x 310 mm
H. 7.III.1
ROGERS FUND, 1931
31.31.12

*D. Isabel de Borbon, Reyna de España,
Muger de Felipe Quarto*
Isabel of Bourbon, Queen of Spain
and Wife of Philip IV
First edition, 1778
Etching and drypoint;
370 x 310 mm
H. 8.III.1
ROGERS FUND, 1931
31.31.11

*D. Baltasar Carlos Principe de España.
Hijo del Rey D. Felipe IV*
Balthasar Carlos, Prince of Spain
and Son of Philip IV
First edition, 1778
Etching and drypoint; 350 x 220 mm
H. 9.III.1
BEQUEST OF GRACE M. PUGH, 1985
1986.1180.899

*Dⁿ. Gaspar de Guzman, Conde de
Olivares, Duque de Sanlucar*
Gaspar de Guzman, Count of Olivares
and Duke of Sanlúcar
First edition, 1778
Etching and drypoint;
370 x 310 mm
H. 10.III.1
ROGERS FUND, 1931
31.31.15

Aesopus
Aesop
First edition, 1778
Etching; 300 x 215 mm
H. 13.III.1
ROGERS FUND, 1931
31.31.16

Moenippus
Menippus
First edition, 1778
Etching; 300 x 220 mm
H. 14.III.1
ROGERS FUND, 1931
31.31.17

Un enano
Portrait of Sebastian de Morra,
Dwarf of Philip IV
First edition, 1778
Etching; 205 x 155 mm
H. 15.III.1
ROGERS FUND, 1931
31.31.14

Un enano
Portrait of El Primo (Diego de Acedo),
Dwarf of Philip IV
First edition, 1778
Etching; 215 x 155 mm
H. 16.III.1
ROGERS FUND, 1931
31.31.18

Las Meninas
The Ladies-in-Waiting
Working proof, ca. 1778
(One of seven surviving examples)
Etching, drypoint, burin, roulette, and
aquatint; 405 x 325 mm
Third state printed in black (recto);
fourth state printed in red (verso)
H. 17.I.3, 4
PROMISED GIFT OF DERALD H. AND JANET
RUTTENBERG *(fig. 3)*

LOS CAPRICHOS

Complete editions

Los Caprichos
The Caprices, plates 1–80
Complete set of the first edition, 1799
Etching, aquatint, drypoint, and burin
H. 36–115.III.1
Ex coll.: Paul J. Sachs (Lugt 2091)
GIFT OF M. KNOEDLER & CO., 1918
18.64(1–80) *(figs. 7, 8)*

Los Caprichos
The Caprices, plates 1–80
Complete set of the fifth edition,
1881–86 (bound in paper boards)
Etching, aquatint, drypoint, and burin
H. 36–115.III.5
GIFT OF MRS. GRAFTON H. PYNE, 1951
51.530.1

Edition impression

El sueño de la razon produce monstruos
The Sleep of Reason
Produces Monsters
Caprichos, plate 43
Ninth edition, 1908–12
Etching and aquatint; 215 x 150 mm
H. 78.III.9
BEQUEST OF GRACE M. PUGH, 1985
1986.1180.895

Working proofs

Tantalo
Tantalus
Caprichos, plate 9
Working proof, 1797–98
Etching and burnished aquatint;
205 x 150 mm
Inscribed below in pen and brown ink:
Para que lo intentas? (crossed out) /
Tantalo
H. 44.I.2
HARRIS BRISBANE DICK FUND, 1930
30.54.42

Estan calientes
They Are Hot
Caprichos, plate 13
Working proof, 1797–98
Etching and aquatint,
before burnishing; 215 x 150 mm
Inscribed below in pen and brown ink:
Estan calientes
H. 48.I.2
HARRIS BRISBANE DICK FUND, 1930
30.54.43

Bellos consejos
A Pretty Piece of Advice
Caprichos, plate 15
Working proof, 1797–98
Etching, engraving, and aquatint, before
burnishing and burin; 215 x 150 mm
Inscribed below in pen and brown ink:
Bellos consejos
H. 50.I.2
HARRIS BRISBANE DICK FUND, 1930
30.54.44

Dios la perdone: y era su madre
For Heaven's Sake: and It Was Her
Mother
Caprichos, plate 16
Working proof, 1797–98
Etching, aquatint, and drypoint;
200 x 150 mm
H. 51.I.2
THE ELISHA WHITTELSEY COLLECTION,
THE ELISHA WHITTELSEY FUND, 1952
52.598

Si quebró el cantaro
Yes, He Broke the Pot
Caprichos, plate 25
Working proof, 1797–98
Etching and aquatint, before drypoint;
215 x 150 mm
Inscribed below in pen and brown ink:
Si quebró el cantaro.
H. 60.I.2
HARRIS BRISBANE DICK FUND, 1930
30.54.45

Printing proofs

Fran.ᶜᵒ Goya y Lucientes, Pintor
Francisco Goya y Lucientes, Painter
Caprichos, plate 1
Proof, before first edition of 1799,
after corrections to the title,
printed in black ink
Etching, aquatint, drypoint, and burin;
215 x 150 mm
H. 36.II.2
Ex coll.: John Singer Sargent
GIFT OF MRS. FRANCIS ORMOND, 1950
50.558.33

Ni asi la distingue
He Cannot Make Her Out
Even This Way
Caprichos, plate 7
Proof, before first edition of 1799,
printed in blackish brown ink

Etching, aquatint, and drypoint;
200 x 150 mm
H. 42.II
GIFT OF WALTER E. SACHS, 1916
16.4.11

Tantalo
Tantalus
Caprichos, plate 9
Proof, before first edition of 1799,
printed in blackish brown ink
Etching and burnished aquatint;
205 x 150 mm
H. 44.II
GIFT OF WALTER E. SACHS, 1916
16.4.8

A caza de dientes
Out Hunting for Teeth
Caprichos, plate 12
Proof, before first edition of 1799,
printed in black ink
Etching, burnished aquatint, and burin;
215 x 150 mm
H. 47.II
GIFT OF WALTER E. SACHS, 1916
16.4.7

Bellos consejos
A Pretty Piece of Advice
Caprichos, plate 15
Proof, before first edition of 1799,
printed in black ink
Etching, burnished aquatint, and burin;
215 x 150 mm
H. 50.II
GIFT OF WALTER E. SACHS, 1916
16.4.10

Bien tirada está
It Is Nicely Stretched
Caprichos, plate 17
Proof, before first edition of 1799,
after correction to the title, printed in
blackish brown ink
Etching, burnished aquatint, and burin;
250 x 150 mm
H. 52.II.2
GIFT OF WALTER E. SACHS, 1916
16.4.9

Mala noche
A Bad Night
Caprichos, plate 36
Proof, before first edition of 1799,
printed in black ink
Etching and burnished aquatint;
215 x 150 mm
H. 71.II
GIFT OF WALTER E. SACHS, 1916
16.4.6

Subir y bajar
To Rise and to Fall
Caprichos, plate 56
Posthumous proof for late edition,
with title masked
Etching and burnished aquatint;
215 x 150 mm

H. 91.III.4–12
GIFT OF DAVID A. JACOBS, 1958
58.531.1

Buen viage
Bon Voyage
Caprichos, plate 64
Posthumous proof for late edition,
with title masked
Etching, burnished aquatint, and burin;
215 x 150 mm
H. 99.III.5–12
GIFT OF DAVID A. JACOBS, 1958
58.531.2

Despacha, que dispiertan
Be Quick, They Are Waking Up
Caprichos, plate 78
Proof, before first edition of 1799,
printed in blackish brown ink
Etching and burnished aquatint;
215 x 150 mm
H. 113.II
HARRIS BRISBANE DICK FUND, 1917
17.3.2977

LOS DESASTRES DE LA GUERRA

Complete editions

Los Desastres de la Guerra
The Disasters of War, plates 1–80
Etched 1810–23
Complete set of the first edition, 1863
(with title page and biography; titles
corrected in plates)
Etching, aquatint, lavis, drypoint, burin,
and burnishing
H. 121–200.III.1.b
PURCHASE, ROGERS FUND AND
JACOB H. SCHIFF BEQUEST, 1922
22.60.25(1–80) (*fig. 14*)

Los Desastres de la Guerra
The Disasters of War, plates 1–80
Etched 1820–23
Complete set of the first edition, 1863
(with title page and biography; titles
corrected in plates)
Etching, aquatint, lavis, drypoint, burin,
and burnishing
H. 121–200.III.1.b
GIFT OF MRS. GRAFTON H. PYNE, 1951
51.530.2(1–80)

Working proofs

Tampoco
Nor Do These
Desastres, plate 10
Working proof, 1810–14
Etching and burin; 150 x 215 mm
H. 130.I.2
HARRIS BRISBANE DICK FUND, 1932
32.62.18

Ni por esas
Neither Do These
Desastres, plate 11

Working proof, before numbers
and lavis, 1810–14
Etching, drypoint, and burin;
160 x 210 mm
H. 131.I.1
HARRIS BRISBANE DICK FUND, 1932
32.62.19

Para eso habeis nacido
This Is What You Were Born For
Desastres, plate 12
Working proof, before numbers
and lavis, 1810–14
Etching, drypoint, and burin;
160 x 235 mm
H. 132.I.2
HARRIS BRISBANE DICK FUND, 1932
32.62.14

Amarga presencia
Bitter to Be Present
Desastres, plate 13
Working proof, before numbers
and lavis, 1810–14
Etching, drypoint, and burin;
145 x 170 mm
H. 133.I.1
HARRIS BRISBANE DICK FUND, 1932
32.62.15

Duro es el paso!
It's a Hard Step!
Desastres, plate 14
Working proof, before numbers
and lavis, 1810–14
Etching, drypoint, and burin;
155 x 165 mm
H. 134.I.1
HARRIS BRISBANE DICK FUND, 1932
32.62.16

Y no hai remedio
And There's Nothing to Be Done
Desastres, plate 15
Working proof, before numbers, 1810–14
Etching, drypoint, burin,
and burnisher; 145 x 165 mm
H. 135.I.1
HARRIS BRISBANE DICK FUND, 1932
32.62.17

Se aprovechan
They Make Use of Them
Desastres, plate 16
Working proof, before numbers,
lavis, burin, or burnisher, 1810–14
Etching and drypoint;
160 x 235 mm
H. 136.I.1
HARRIS BRISBANE DICK FUND, 1932
32.62.13

No se convienen
They Do Not Agree
Desastres, plate 17
Working proof,
before numbers, 1810–14
Etching, drypoint, burin,
and burnisher; 145 x 215 mm

H. 137.I.2
HARRIS BRISBANE DICK FUND, 1930
30.54.46

Enterrar y callar
Bury Them and Keep Quiet
Desastres, plate 18
Working proof,
before numbers or lavis, 1810–14
Etching, drypoint, and burin;
160 x 235 mm
H. 138.I.2
HARRIS BRISBANE DICK FUND, 1932
32.62.12

Curarlos, y á otra
Get Them Well, and On to the Next
Desastres, plate 20
Working proof,
before numbers,
dated 1810
Etching, lavis, burin, and burnisher;
160 x 235 mm
H. 140.I.2
HARRIS BRISBANE DICK FUND, 1932
32.62.7

Será lo mismo
It Will Be the Same
Desastres, plate 21
Working proof,
before numbers or lavis, 1810–14
Etching; 145 x 220 mm
H. 141.I.1
HARRIS BRISBANE DICK FUND, 1932
32.62.8

Tanto y mas
Even Worse
Desastres, plate 22
Working proof, before numbers
or lavis, dated 1810
Etching and burin;
160 x 250 mm
H. 142.I.2
HARRIS BRISBANE DICK FUND, 1932
32.62.9

Lo mismo en otras partes
The Same Elsewhere
Desastres, plate 23
Working proof, before numbers
or lavis, 1810–14
Etching, drypoint, and burin;
160 x 240 mm
H. 143.I.2
HARRIS BRISBANE DICK FUND, 1932
32.62.3

Aun podrán servir
They Can Still Be of Use
Desastres, plate 24
Working proof, before numbers,
1810–14
Etching and burnisher;
160 x 255 mm
H. 144.I.1
HARRIS BRISBANE DICK FUND, 1932
32.62.10

Tambien estos
These Too
Desastres, plate 25
Working proof, before numbers, 1810–14
Etching, drypoint, and burin;
165 x 235 mm
H. 145.I.2
HARRIS BRISBANE DICK FUND, 1932
32.62.4

Caridad
Charity
Desastres, plate 27
Working proof, before numbers
and lavis, dated 1810
Etching, drypoint, and burin;
160 x 235 mm
H. 147.I.3
HARRIS BRISBANE DICK FUND, 1932
32.62.1

Estragos de la guerra
Ravages of War
Desastres, plate 30
Working proof, before numbers, 1810–14
Etching, drypoint, burin,
and burnisher; 140 x 170 mm
H. 150.I.1
HARRIS BRISBANE DICK FUND, 1932
32.62.5

Tampoco
Not This Time Either
Desastres, plate 36
Working proof, before border lines,
1810–14
Printed ca. 1823
Etching, burnished aquatint,
drypoint, burin, and burnisher;
155 x 205 mm
H. 156.I.3
PURCHASE,
DERALD H. AND JANET RUTTENBERG,
DR. AND MRS. GOODWIN M. BREININ,
ARTHUR ROSS FOUNDATION, AND
PETER H. B. FRELINGHUYSEN GIFTS, AND
THE ELISHA WHITTELSEY COLLECTION,
THE ELISHA WHITTELSEY FUND, 1987
1987.1014

Escapan entre las llamas
They Escape through the Flames
Desastres, plate 41
Working proof, before numbers, 1810–14
Etching and burin; 160 x 235 mm
H. 161.I.2
HARRIS BRISBANE DICK FUND, 1932
32.62.6

Yo lo vi
I Saw It
Desastres, plate 44
Working proof,
before numbers, 1810–14
Etching, drypoint, and burin;
160 x 235 mm
H. 164.I.1
HARRIS BRISBANE DICK FUND, 1932
32.62.2

Al cementerio
To the Cemetery
Desastres, plate 56
Working proof, before lavis and
with earlier number 30, 1810–14
Etching and drypoint; 155 x 205 mm
H. 176.I.2
HARRIS BRISBANE DICK FUND, 1953
53.541

No hay que dar voces
It's No Use Crying Out
Desastres, plate 58
Working proof,
with earlier number 34, 1810–14
Etching, aquatint, burin,
and burnisher; 155 x 205 mm
H. 178.I.3
HARRIS BRISBANE DICK FUND, 1953
53.540

LA TAUROMAQUIA

Complete edition

La Tauromaquia
The Bullfight, plates 1–33
Complete set of the first edition, 1816
Etching, aquatint, drypoint, burin,
and burnishing
H. 204–36.III.1
ROGERS FUND, 1921
21.19.1–33 *(fig. 19)*

Edition impressions

Cogida de un moro estando en la plaza
A Moor Caught by the Bull in the Ring
Tauromaquia, plate 8
Third issue of the first edition, 1816
Etching, burnished aquatint,
and drypoint; 245 x 350 mm
H. 211.III.1
GIFT OF WALTER E. SACHS, 1916
16.4.4

*Carlos V. lanceando un toro en la plaza
de Valladolid*
Charles V Spearing a Bull in the Ring
at Valladolid
Tauromaquia, plate 10
Third issue of the first edition, 1816
Etching, burnished aquatint, drypoint,
and burin; 250 x 350 mm
H. 213.III.1
GIFT OF WALTER E. SACHS, 1916
16.4.2

*Ligereza y atrevimiento de Juanito Apiñani
en la de Madrid*
The Agility and Audacity of Juanito
Apiñani in the [Ring] at Madrid
Tauromaquia, plate 20
Third issue of the first edition, 1816
Etching and aquatint;
245 x 355 mm
H. 223.III.1
GIFT OF WALTER E. SACHS, 1916
16.4.3

The Dogs Let Loose on the Bull
Tauromaquia, plate C
Posthumous fourth edition, 1905
One of seven additional plates for
the *Tauromaquia,* first published by
E. Loizelet in 1876
Etching, burnished aquatint and/or
lavis, drypoint, and burin;
245 x 350 mm
H. 239.III.4
BEQUEST OF GRACE M. PUGH, 1985
1986.1180.898

Cogida de un moro estando en la plaza
A Moor Caught by the Bull
in the Ring
Tauromaquia, plate 8
Posthumous seventh edition, 1937
Etching, burnished aquatint, and
drypoint; 245 x 350 mm
H. 211.III.7
BEQUEST OF GRACE M. PUGH, 1985
1986.1180.896

DISPARATES

Complete edition

Disparates (Los Proverbios)
The Follies, plates 1–18
Etched ca. 1816–23
Posthumous first edition
(with engraved list of plates), 1864
Etching, aquatint, lavis, drypoint, burin,
and burnishing
H. 248–65.III.1
HARRIS BRISBANE DICK FUND, 1924
24.30.1, 2, 5, 7–9, 11, 13–16, 18
GIFT OF MRS. HENRY J. BERNHEIM, 1936
36.20 (3, 4, 6, 10, 12, 17)

Published impression

Disparate de tontos (or *toritos*)
Fools' (or Little Bulls') Folly
Disparates, plate D
Printed by François Liénard
in *L'Art,* 1877, with title
Lluvia de toros / Pluie de taureaux
(Rain of Bulls)
Etching, aquatint, and drypoint(?);
245 x 350 mm
H. 269.III
BEQUEST OF GRACE M. PUGH, 1985
1986.1180.900

Posthumous proofs

Disparate femenino
Feminine Folly
Disparates, plate 1
Posthumous proof, 1848–62
Etching, aquatint, and drypoint(?);
240 x 350 mm
H. 248.II
Ex coll.: British Museum (duplicate)
(Lugt 302 [1862], 305)
HARRIS BRISBANE DICK FUND, 1932
32.78.2

Soldiers Frightened by a Phantom
Disparates, plate 2
Posthumous proof, before scratch
and before obscuring of the hills
and the tree in the distance, ca. 1848
Etching, burnished aquatint, and
drypoint; 245 x 350 mm
H. 249.II.1
Ex coll.: Philippe Burty (Lugt 2071);
Alfred Beurdeley (Lugt 421)
ROGERS FUND, 1921
21.54.2 *(fig. 16)*

Bobalicón
The Dancing Giant
Disparates, plate 4
Posthumous proof, before number,
1848–63
Etching, burnished aquatint, burin,
and drypoint(?);
245 x 350 mm
H. 251.II
Ex coll.: Philippe Burty (Lugt 2071);
Alfred Beurdeley (Lugt 421)
ROGERS FUND, 1921
21.54.1

Disparate volante
Flying Folly
Disparates, plate 5
Posthumous proof, before number,
1848–63
Etching and aquatint; 245 x 350 mm
H. 252.II
Ex coll.: Philippe Burty (Lugt 413)
HARRIS BRISBANE DICK FUND, 1932
32.78.3

A Man Mocked
Disparates, plate 17
Posthumous proof, 1848–63
Etching and burnished aquatint;
240 x 350 mm
H. 264.II
GIFT OF MISS ANNA PELLEW, 1922
22.4

Old Man Confronting Phantoms
Disparates, plate 18
Posthumous proof, dryly inked,
1848–63
Etching, burnished aquatint, and burin;
245 x 350 mm
H. 265.II
Ex coll.: Philippe Burty (Lugt 413)
HARRIS BRISBANE DICK FUND, 1931
31.79.2

Disparate conocido
Well-Known Folly
Disparates, plate A
Posthumous proof
on China paper,
before 1877
Etching and burnished aquatint;
245 x 350 mm
H. 266.II
ROGERS FUND, 1922
22.63.146

Disparate conocido
Well-Known Folly
Disparates, plate A
Posthumous proof
on China paper,
before 1877
Etching and burnished aquatint;
245 x 350 mm
H. 266.II
GIFT OF HARRY G. FRIEDMAN, 1962
62.635.798

Disparate puntual
Punctual Folly
Disparates, plate B
Posthumous proof
on China paper,
before 1877
Etching, aquatint, and drypoint(?);
245 x 350 mm
H. 267.II
ROGERS FUND, 1919
19.64

Disparate de bestia
Animal Folly
Disparates, plate C
Posthumous proof
on China paper,
before 1877
Etching, aquatint, and drypoint(?);
245 x 350 mm
H. 268.II
ROGERS FUND, 1922
22.63.147

Disparate de tontos (or *toritos*)
Fools' (or Little Bulls') Folly
Disparates, plate D
Posthumous proof
on China paper,
before 1877
Etching, aquatint, and drypoint(?);
245 x 350 mm
H. 269.II
ROGERS FUND, 1922
22.63.145

BORDEAUX ETCHINGS

Maja against a Background of Demons
Etched 1824–28
Posthumous edition made for
John Savile Lumley, 1859
Etching and aquatint; 191 x 123 mm
H. 30.III
Ex coll.: Philippe Burty (Lugt 413);
British Museum (duplicate)
(Lugt 302 [1876], 305)
HARRIS BRISBANE DICK FUND, 1923
23.37.6

After Goya(?)
Maja (on light background)
Posthumous proof, before Lumley
edition of 1859
Etching; 191 x 123 mm
H. 31.II
Ex coll.: Alfred Beurdeley (Lugt 421)
HARRIS BRISBANE DICK FUND, 1924
24.97.2

After Goya(?)
Andalusian Smuggler with Bull
Posthumous edition made for
John Savile Lumley, 1859
Etching and drypoint; 191 x 123 mm
H. 34.III
Ex coll.: Philippe Burty (Lugt 413);
British Museum (duplicate)
(Lugt 302 [1876], 305)
HARRIS BRISBANE DICK FUND, 1923
23.37.5

*Guitarist against a Background of Demons
(Blind Guitarist)*
Etched 1824–28
Posthumous proof
Etching, aquatint, drypoint, and burin;
190 x 120 mm
H. 35.II
Ex coll.: British Museum (duplicate)
(Lugt 302 [1908], 305)
HARRIS BRISBANE DICK FUND, 1927
27.32.2

Late Caprichos of Goya
Bound text by Eleanor Sayre and six
plates printed by Emiliano Sorini, 1971
Etching, aquatint, drypoint, and burin
H. 30–34
ADMINISTRATIVE PURCHASE FUND, 1972
1972.507.1–6

BULLS OF BORDEAUX

El famoso Americano, Mariano Ceballos
The Famous American, Mariano
Ceballos, 1825
Lithograph; 305 x 400 mm
H. 283.II
BEQUEST OF MRS. LOUIS H. PORTER, 1946
46.103

[*Bravo toro*]
Picador Caught by a Bull, 1825
Lithograph; 305 x 410 mm
H. 284.II
ROGERS FUND, 1920
20.60.2

Dibersion de España
Spanish Entertainment, 1825
Lithograph; 300 x 410 mm
H. 285.II
ROGERS FUND, 1920
20.60.3

The Divided Ring, 1825
Lithograph; 300 x 415 mm
H. 286.II
ROGERS FUND, 1920
20.60.4 (*fig. 20*)

FORMERLY ATTRIBUTED TO
GOYA

Men Spitting at a Fire
Unique impression
Lithograph; 120 x 170 mm
D. 3 (doubtful attribution); not in H.
THE ELISHA WHITTELSEY COLLECTION,
THE ELISHA WHITTELSEY FUND, 1962
62.600.326

Portrait of a Young Man, ca. 1820
Lithograph; 225 x 185 mm
D. 285; H. 292 (attributed)
Ex coll.: Frédéric Villot; Philip and
Frances Hofer
PURCHASE, BEQUEST OF CHESTER DALE,
BY EXCHANGE, AND ANNE STERN GIFT,
1993
1993.1046

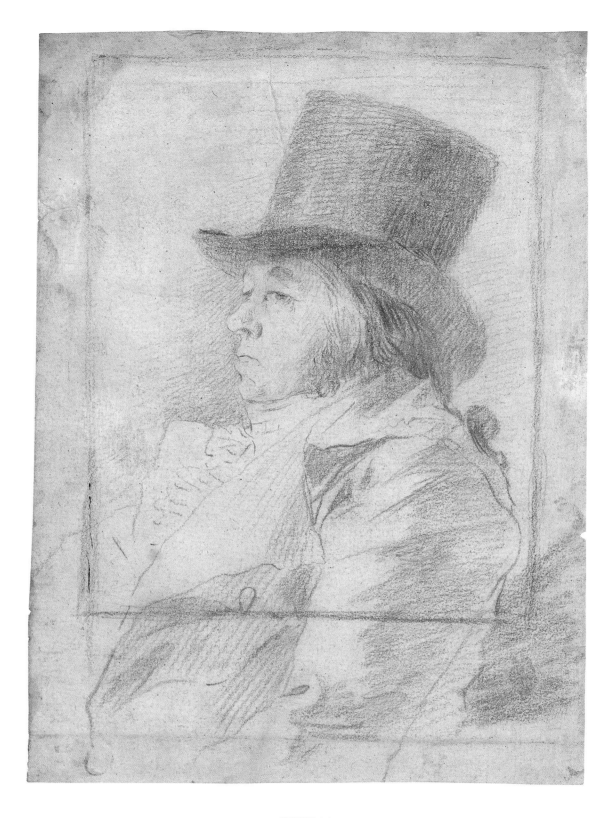

FIGURE 44

Self-Portrait, ca. 1797–98. Red chalk; 200 x 143 mm.
BEQUEST OF WALTER C. BAKER, 1971 (1972.118.295)

Museum Exhibitions and Publications of Goya's Works

EXHIBITIONS

1946	"Masterpieces from the Department of Prints." May 3–September 30.
1948–49	"Lithographs." December 3, 1948–April 18, 1949.
1950–51	"Goya Prints and Drawings." November 3, 1950–March 1951.
1952–53	"Bresdin and Masters of the Weird." November 22, 1952–March 2, 1953.
	"Art Treasures of the Metropolitan." November 7, 1952–September 7, 1953.
1953	"Recent Accessions." September 24–December 7.
1954	"Loan Exhibition of the Lehman Collection." January 9 (opened).
1955	"Goya: Drawings and Prints." May 4–30.
1957	"Paintings from the São Paulo Museum." March 21–May 5.
1958	"Paintings from Private Collections, Summer Loan Exhibition." July 2–September 1.
1960	"Drawings from the Collection of Walter C. Baker." June 2–September 4.
	"Paintings from Private Collections, Summer Loan Exhibition." July 6–September 4.
1961	"Spectacular Spain." February 4–May 24.
1963	"Tastes and Curiosities of a Curator." February 8–June 3.
1965	"Master Prints." September 19–October 24.
1970	"Against Violence: Callot, Goya, and Daumier." July 21–August 16.
	"One Hundred Years of the Print Department: A Survey of Acquisitions During the Museum's First Century." July 21–September 7.
1970–71	"Masterpieces of Fifty Centuries." November 14, 1970–June 1, 1971.
1972	"Portrait of the Artist." January 18–March 7.
	"Prints & People." April 25–June 7.
1975–76	"Patterns of Collecting: Selected Acquisitions 1965–1975." December 6, 1975–March 23, 1976.
1976	"Goya: Paintings from the Prado." June 5–August 8.
1979	"Old Master and Modern Prints." August 28–November 4.
1980	"A. Hyatt Mayor: Favored Prints." May 13–July 6.
1987	"Recent Acquisitions." June 16–August 16.
1988–89	"Recent Acquisitions: Drawings, Prints and Photographs." September 20, 1988–January 8, 1989.
1989	"Spain: Drawings, Prints, and Photographs." April 18–July 16.
	"Goya and the Spirit of Enlightenment." May 9–July 16.
1992–93	"Masterworks from the Musée des Beaux-Arts, Lille." October 27, 1992–January 17, 1993.
1993	"Splendid Legacy: The Havemeyer Collection." March 27–June 20.
1993–94	"Nineteenth-Century Portraits, Landscapes, and Nudes." September 10, 1993–January 2, 1994.

PUBLICATIONS

1906	[Fry, Roger]. "Principal Accessions: Portrait of Don Sebastian Martinez, by Goya." *MMA Bulletin* 1, no. 5 (April), p. 73.
1917	I[vins], W[illiam] M., Jr. "Accessions and Notes: Department of Prints, Gifts." *MMA Bulletin* 12, no. 2 (February), p. 40.
	Cox, Kenyon. "Workmanship." *MMA Bulletin* 12, no. 7 (July), pp. 150–53.
1918	I[vins], W[illiam] M., Jr. "Goya's Caprices." *MMA Bulletin* 13, no. 7 (July), p. 162.
1919	B[urroughs], B[ryson]. "Drawings among the Recent Accessions." *MMA Bulletin* 14, no. 8 (August), pp. 176–78.
1920	I[vins], W[illiam] M., Jr. "Etchings in the Print Galleries." *MMA Bulletin* 15, no. 7 (July), pp. 164–67.
1921	I[vins], W[illiam] M., Jr. "Five Years in the Department of Prints." *MMA Bulletin* 16, no. 12 (December), p. 260.
1923	B[urroughs], B[ryson]. "A Bull Fight by Goya." *MMA Bulletin* 18, no. 3 (March), pp. 64–66.
1924	I[vins], W[illiam] M., Jr. "Goya's Disasters of War." *MMA Bulletin* 19, no. 9 (September), pp. 220–24.
1928	Ivins, W[illiam] M., Jr. "A Note apropos of Two Anniversaries." *MMA Bulletin* 23, no. 1 (January), pp. 25–27.
	Burroughs, Bryson. *Catalogue of an Exhibition of Spanish Paintings from El Greco to Goya.*
	Burroughs, Bryson. "Spanish Paintings from El Greco to Goya." *MMA Bulletin* 23, no. 2 (February), pp. 39–44.

Ivins, William M., Jr. "A Goya Exhibition." *MMA Bulletin* 23, no. 10 (October), pp. 230–32.

1934–36 Ivins, William M., Jr. "Goya's Giant." *MMA Studies* 5, p. 182.

1935 Mayor, A. Hyatt. "Goya's Giant." *MMA Bulletin* 30, no. 8 (August), pp. 153, 154.

1936 Winlock, H. E. "A Goya Exhibition." *MMA Bulletin* 31, no. 1 (January), p. 2.

Francisco Goya: His Paintings, Drawings and Prints. Exh. cat. Preface by H. E. Winlock; introductory text by William M. Ivins, Jr.; catalogue notes by Harry B. Wehle, Louise Burroughs, and A. Hyatt Mayor.

"An Exhibition of the Work of Goya." *MMA Bulletin* 31, no. 2 (February), pp. 21, 22.

Wehle, Harry B. "An Album of Goya's Drawings." *MMA Bulletin* 31, no. 2 (February), pp. 23–28.

1937 Wehle, Harry B. "A Miniature by Goya." *MMA Bulletin* 32, no. 5 (May), pp. 131–32.

1938 Wehle, Harry B. *Fifty Drawings by Francisco Goya.* MMA Papers, no. 7. Reprinted 1941.

1940 Wehle, Harry B. *A Catalogue of Italian, Spanish and Byzantine Paintings,* pp. 246–54, 301.

1945 Ivins, William M., Jr. "Goya." *MMA Bulletin,* n.s. 3, no. 10 (June), pp. 235–37.

1946 Mayor, A. Hyatt. "Goya's Creativeness." *MMA Bulletin,* n.s. 5, no. 4 (December), pp. 105–9.

1949 Gardner, Elizabeth E. "Notes." *MMA Bulletin,* n.s. 7, no. 10 (June), facing p. 260.

1951 *Masters of Spanish Painting: El Greco, Goya, Velazquez and Others.* MMA Miniatures [28].

1953 Mayor, A. Hyatt. *Goya, 1746–1828.* MMA Miniatures [47].

1955 "Goya: Drawings and Prints. Catalogue Supplement. Paintings, drawings and prints added to the exhibition for the showing at The Metropolitan Museum of Art from May 4 through May 30, 1955." Leaflet checklist.

"Notes—Goya: Drawings and Prints." *MMA Bulletin,* n.s. 13, no. 9 (May), facing p. 257.

1964 Bean, Jacob. *100 European Drawings in The Metropolitan Museum of Art,* nos. 92–95.

Mayor, A. Hyatt. *MMA Guide to the Collections: Prints,* pp. 23–25.

1967 Virch, Claus. *Francisco Goya.* Color Slide Program of the Great Masters. New York: McGraw-Hill.

1970 *Masterpieces of Fifty Centuries.* Exh. cat. Introduction by Kenneth Clark. Nos. 327–31. New York: Dutton.

1971 Mayor, A. Hyatt. *Prints & People: A Social History of Printed Pictures,* nos. 344, 622, 624–31. Reprinted in paperback, Princeton University Press, 1980.

1972 *Portrait of the Artist.* Exh. cat. by John Walsh, Jr., with the assistance of Weston J. Naef and Miranda McClintic. Nos. 15, 16.

1973 Fahy, Everett. "Outstanding Recent Accessions— European Paintings: Goya's Portrait of Pepito Costa y Bonells." *MMA Bulletin,* n.s. 31, no. 4 (Summer), pp. 174–75.

1974 Mayor, A. Hyatt. *Goya: 67 Drawings.*

1976 *Goya: Paintings from the Prado.* Exh. cat. Text by Marcus B. Burke.

1987 I[ves], C[olta] F. "Prints and Photographs: Tampoco." In *Recent Acquisitions: A Selection 1986–1987,* p. 49.

MMA: Europe in the Age of Enlightenment and Revolution. Introduction by J. Patrice Marandel. Pp. 74–81.

1992 *Masterworks from the Musée des Beaux-Arts, Lille.* Exh. cat. Nos. 34, 35, by Anne Norton.

1993 *Splendid Legacy: The Havemeyer Collection.* Exh. cat. See esp. Gary Tinterow, "The Havemeyer Pictures," pp. 12–17; Susan Alyson Stein, "Chronology," pp. 222ff.; Gretchen Wold, "Appendix," pp. 343–45.

Masterpieces of The Metropolitan Museum of Art. Introduction by Philippe de Montebello. Pp. 200–201, 215.

Selected Bibliography

Baticle, Jeannine. *Goya.* Paris: Fayard, 1992.

D.
Delteil, Loys. *Le peinture graveur illustré.* Vols. 14 and 15, *Francisco Goya.* Paris, 1922.

G. I
Gassier, Pierre. *Francisco Goya, Drawings: The Complete Albums.* Translated by James Emmons and Robert Allen. New York: Praeger, 1973.

G. II
Gassier, Pierre. *The Drawings of Goya: The Sketches, Studies and Individual Drawings.* Translated from French. New York: Harper and Row, 1975.

G.-W.
Gassier, Pierre, and Juliet Wilson. *The Life and Complete Work of Francisco Goya, with a Catalogue Raisonné of the Paintings, Drawings and Engravings.* French ed., 1970. Rev. English ed. (published in Great Britain under the title *Goya: His Life and Work*). New York: Reynal, in association with William Morrow, 1971.

Glendinning, Nigel. *Goya and His Critics.* New Haven and London: Yale University Press, 1977.

Gudiol, José. *Goya, 1746–1828: Biography, Analytical Study, and Catalogue of His Paintings.* Translated by Kenneth Lyons. 4 vols. New York: Tudor, 1971.

H.
Harris, Tomás. *Goya: Engravings and Lithographs.* Vol. 1, *Text and Illustrations.* Vol. 2, *Catalogue Raisonné.* Oxford: Bruno Cassirer, 1964.

Held, Jutta, ed. *Goya; Neue Forschungen. Das internationale Symposium 1991 in Osnabrück.* Berlin: Gebr. Mann, 1994.

Licht, Fred. *Goya: The Origins of the Modern Temper in Art.* New York: Universe Books, 1978.

López Rey, José. *Goya's Caprichos: Beauty, Reason and Caricature.* Princeton: Princeton University Press, 1953.

Lugt, Frits. *Les marques de collections de dessins et d'estampes....* Amsterdam: Vereenigde, 1921. *Supplément.* The Hague: M. Nijhoff, 1956.

Muller, Priscilla E. *Goya's "Black" Paintings: Truth and Reason in Light and Liberty.* New York: Hispanic Society of America, 1984.

Nordström, Folke. *Goya, Saturn and Melancholy: Studies in the Art of Goya.* Acta Universitatis Upsaliensis. *Figura,* n.s. 3. Stockholm, 1962.

Pérez Sánchez, Alfonso, and Eleanor A. Sayre, et al. *Goya and the Spirit of Enlightenment.* Boston: Museum of Fine Arts, 1989.

Sayre, Eleanor A., and the Department of Prints and Drawings. *The Changing Image: Prints by Francisco Goya.* Boston: Museum of Fine Arts, 1974.

Tomlinson, Janis. *Graphic Evolutions: The Print Series of Francisco Goya.* New York: Columbia University Press, 1989.

———. *Goya in the Twilight of Enlightenment.* New Haven and London: Yale University Press, 1992.

———. *Francisco Goya y Lucientes, 1746–1828.* London: Phaidon, 1994.

Trapier, Elizabeth du Gué. *Goya and His Sitters: A Study of His Style as a Portraitist.* New York: Hispanic Society of America, 1964.

Wilson-Bareau, Juliet. *Goya's Prints: The Tomás Harris Collection in the British Museum.* London: British Museum Publications, 1981.

———. *Goya, Truth and Fantasy: The Small Paintings.* New Haven and London: Yale University Press, 1994.